Ruth DiConti

Ruth DiConti

John Boulton Smith

MUNCH

PHAIDON

The author and publishers would like to thank all those museum authorities and private owners who have kindly allowed works in their possession to be reproduced.

The author wishes to acknowledge his debt to writings by Henning Gran, Reinhold Heller, Ingrid Langaard, Johan H. Langaard and Reidar Revold, Nic Stang, and to publications of the Munch-Museet, from which quotations have been drawn. Many of their publications are listed in the bibliography.

Phaidon Press Limited, Littlegate House, St Ebbe's Street, Oxford
Published in the United States of America by E. P. Dutton, New York

First published 1977

© *1977 by Phaidon Press Limited*

ISBN 0 7148 1799 6

Library of Congress Catalog Card Number: 77-80141

Printed in Great Britain

MUNCH

Edvard Munch is the only Scandinavian painter to have been recognized internationally as a great modern master. This recognition was achieved first in Germany, then in Scandinavia and Central Europe, and has rested largely on his importance in the growth of Expressionism and as a pioneer of modern printmaking. In fact his range of style and subject is greater than this might suggest. Throughout his career ran the desire to communicate to a public statements of a psychological or philosophical nature about mankind. To this end, mural decoration became an aim of increasing importance to him, as also did printmaking with its possibilities of wide distribution. But his mastery in other fields is also important, covering portraiture, landscape painting, scenes of working life, and subjects inspired by literature. Yet – despite his determination to communicate with a public (confirmed by the exceptionally long list of his exhibitions) – he was a highly subjective artist who believed that his motifs should be drawn from his own experiences. Throughout his life Munch kept up a wonderful series of self-portraits and it is instructive to compare how he saw himself at thirty-two (Plate 1), forty-six (Plate 2), and seventy-eight (Plate 3). However, although his art is so autobiographical, its inspiration shows frequent similarities with that of his contemporaries; introspection was popular among *fin-de-siècle* artists, especially in northern countries. Moreover his idiom would hardly have crystallized in the way it did without the example of French Post-Impressionism.

Munch was born in 1863 into a professional family, which had included an artist, a writer, a bishop and a brilliant historian. His father was a doctor and, although his practice was not very lucrative, the home was a united and cultured one. Tragic illness struck early. Tuberculosis killed Munch's mother when he was only five, and his sister Sophie nine years later. His brother Andreas was to die at thirty, while another sister, Laura, later became mentally ill. The artist grew up afraid of illness, and fearing that he came of tainted stock: 'Illness, insanity and death were the black angels that kept watch over my cradle and accompanied me all my life'. His mother's place was taken by her unmarried sister, Karen Bjølstad, who became the centre of the household, and encouraged the boy's artistic talent. After his wife's death, Dr. Munch became more gloomy and puritanical, and a rift developed between father and son. Yet Edvard sincerely loved his father, and was badly disturbed when he died. Although the pattern of his life was to become so different, Munch retained a strong sense of family. He was well aware how much his art owed to this background.

After a false start as an engineering student, Munch entered the School of Design in Oslo in 1881. His earliest paintings are small, tightly-drawn studies from his home or Oslo scenes, which hardly indicate the scale of his potential talent. But development came quickly. *From Maridalen* (Plate 4), of 1881, already shows a more relaxed naturalism, while by 1884 he could be brilliant and atmospheric on a larger scale with *Girl on the Edge of the Bed* (Plate 5).

The Oslo (or Christiania, as it was called until 1925) of Munch's youth was still a small, rather provincial town, firmly bourgeois and Protestant in its way of life. Art patronage was very limited, and most artists and writers of exceptional talent worked abroad. But the eighteen-eighties were to see many changes. More artists now started to return and settle in Norway, after completing their studies abroad. This led to innovations in the country's artistic life, notably the inauguration of the Autumn Exhibition, Norway's

principal officially supported open exhibition of the year. Moreover, the spirit of National Romanticism, which had dominated so much nineteenth-century Norwegian art, was now fading, and being replaced by the new Realism from France. Artists like Bastien-Lepáge and Manet, Corot and Daubigny, became models for the younger painters, Flaubert and Zola for the writers. Artists also brought home with them the habits of café life and the easy moral standards of Bohemian life in Paris; the 1880s saw the growth of the *Christiania Bohème*, a circle named after a novel by Hans Jaeger, one of its leaders.

Jaeger attacked the accepted Christian moral code of Oslo's bourgeois establishment, and his outspoken advocacy of atheism, anarchy and free love earned him a spell in prison. Much of this appealed to the young Munch, offering an alternative to his father's puritanical values. Advocacy of sexual freedom would have encouraged a young man as handsome as he was, but even more important was Jaeger's insistence that one's art should be based on one's own life. Although he later came to reject many of Jaeger's doctrines, the artist followed this one throughout his life. Another prominent Bohemian was Christian Krohg, eleven years Munch's senior, whose novel and painting about the career of a prostitute scandalized Oslo. He edited the circle's newspaper, *The Impressionist*, but in fact his paintings stopped short of full Impressionism. Impressionism in Norway of the 1880s meant an impressionistic Realism, rather in the manner of Manet. From 1882, Krohg gave Munch some assistance, and *Girl on the Edge of the Bed* (Plate 5) is Krohg-like in both colour and choice of subject. However, the older artist would probably have given the motif social-realist overtones, while Munch is more sensitive to the vibrations of light. Another follower of French naturalism was Frits Thaulow, who for two summers ran an open-air painting school in Norway, which Munch attended. A third artist, whom Munch particularly admired for his sensitive painterly qualities, was Hans Heyerdahl.

By the mid-1880s Munch had embraced what he called 'Impressionism and Realism', and this characterized most of his work during the rest of the decade. A short visit to Paris in 1885, where he particularly admired work by Rembrandt, Velazquez and Manet, probably strengthened this. But in 1886 he completed a masterpiece which anticipated the mature Munch, *The Sick Child* (Plate 6). The artist always regarded this painting as a turning point, and he later returned to the motif many times in both painting and prints (Plate 7). In it he combined a vivid visual experience (the grief-stricken face of a girl, observed while Dr. Munch was attending to her small brother's broken leg) with personal memories (the death of his own sister) to express a tragedy with universal meaning – youth and death. Munch achieved this expressive concentration through simplification and technical experiment, scraping down details to focus attention on the head, the emotional and compositional centre of the picture. Today its mastery is obvious, but contemporary Norwegian critics were blinded by the revolutionary technique to the fact that the subject was a common one in the late nineteenth century. They could only see 'a disconnected collection of coloured spots . . . completely lacking any emotional content'. Two other important paintings of 1886, *Puberty* and *The Morning After*, were unfortunately destroyed, so we can only form an opinion from the versions he re-created in the 1890s. In contrast to *The Sick Child*, *Puberty* (Plate 8) imaginatively represents a girl's anxiety as she looks forward to life, a remarkably perceptive painting for a young man. *The Morning After* records more factually a typical scene from Bohemian life.

Munch continued to follow 'Impressionism and Realism' until 1889 when, as he wrote, he took leave of it with his large painting *Spring*. On the same subject as *The Sick Child*, this picture, although masterly, is considerably more conventional, and the artist may well have regarded it as a demonstration piece in support of the application for a state scholarship to study abroad which he made that year. 1889 was a prolific year. In *Summer*

Night. (Inger on the Shore) (Plate 10) he turns a study of his sister into a mood picture of the mysterious northern twilight, anticipating his important theme of the 1890s: the solitary figure by the water's edge. His portraits showed remarkable psychological insight, as in *Hans Jaeger* (Plate 14), slouched defiantly behind his drink. When Munch held his first one-man exhibition that year, his mastery was recognized by a number of prominent artists, if not by the public. His application for a scholarship was granted, and by October he was in Paris.

France was to be Munch's main base until 1892, although he returned to Norway for the summers. It was the period when he consciously started to identify the aims of his art, and to search out forms from modern painting with which to express it. He had barely been in Paris a month when he heard news of his father's death. This upset him deeply. The conflict between Jaeger's revolutionary principles and Dr. Munch's intense Christian beliefs had caused disturbing differences between father and son in recent years, and there could now be no reconciliation. Munch was conscience stricken and he began to re-assess the values he had learnt from Jaeger. He began consciously to reject Realism for the ideal of an inward-looking art which, if not orthodoxly religious, was to be serious and spiritual. During the winter of 1889–90, living at St. Cloud, he noted down his new aim:

'No longer shall interiors be painted with people reading and women knitting.

'There shall be living people who breathe and feel and suffer and love.

'I will paint a number of such pictures.

'People will understand what is sacred in them and will take off their hats as if in church.'

At the same time he painted *Night in St. Cloud* (Plate 9), probably a *memento mori* occasioned by his father's death. A brooding figure sits by the window of a dark room, while light from outside casts a cross-like shadow on the floor. The predominant colour is blue, which Munch had recently found was used by the Greeks to symbolize death.

It was probably in Nice, in winter 1891, that he wrote down an even more explicit artistic credo. After ridiculing those who can only accept naturalistic colour and who therefore are not prepared to comprehend his 'impressions', he continues:

'In these paintings, then, the painter depicts his deepest emotions. They depict his soul, his sorrows and joys. They display his heart's blood.

'He depicts the human being, not the object.

'These paintings are made to move people more intensely'. And he explains how complementary colour in the optical after-image can create the essential mood:

'Go into the billiard room. After you have looked on that intense green table-cover for awhile, look up. How strangely red everything is! Those men you know were dressed in black now are dressed in crimson red, and the room – the walls and ceiling – is red.

'After some time, the clothing is black again. But if you want to paint an emotional mood like that, with a billiard table, then you must paint it crimson red.

'If one wants to paint the impressions of a moment, the emotional mood, then this is what one has to do.'

In another statement Munch clearly reveals his relation to Realism: 'I paint not what I see, but what I saw.' Forty years later he summed up his practice: 'I do not finish a work until I am a bit removed from the vision of it so that my memory can clarify its emotional impressions. Nature confuses me when I have it directly in front of me.'

Similar aims had been expressed by the great Romantics, and also by Munch's contemporaries. Van Gogh's description of his *Night Café*, where he 'tried to express the terrible passions of humanity by means of red and green', is close, although Munch could not have known this passage when he made his notes. They also unite him with

5

Nyromantikken (Neo-Romanticism), the new Norwegian artistic movement of the 1890s. Its writers, Vilhelm Krag, Sigbjørn Obstfelder and Knut Hamsun, all friends of Munch, also reacted against Realism while retaining autobiographical sources of inspiration. In 1890 Hamsun wrote: 'What if literature were to begin to occupy itself now more with psychological states than with romances and dances more in keeping with the spiritual life lived by the mature modern man. . . . We would discover . . . in short, all the subconscious life of the soul'. How like the title which Munch later gave to his *Life Frieze – Motifs from the Life of a Modern Soul*. In painting, Neo-Romanticism appeared as symbolic human dramas or mood-landscapes of the mysterious northern twilight, both basic genres with Munch.

In evolving the means to express his new programme, Munch looked around him. He had at first studied for a few months with the noted academic artist Léon Bonnat, but modern art obviously attracted him much more strongly. He would have seen mature Impressionism and its Neo-Impressionist development; his *Spring Day on Karl Johan Street* (Plate 12) shows the influence of both. Whistler was then at the height of his Parisian fame, and influences from his blue nocturnes appear in works like *Night in St. Cloud* (Plate 9), while Munch's original name, *Black and Violet*, for the standing portrait of his sister Inger (Plate 15) recalls the 'abstract' titles of the American. Munch's steep, shooting perspectives suggest that he saw works by Van Gogh, with whom he has many affinities. He must also have heard something of Gauguin, who had exhibited early work at the Oslo Autumn Exhibition during the 1880s. He probably saw works by Gauguin's followers in the 1891 exhibition of the Indépendants (which also included a retrospective show of Van Gogh's work), especially that of his Danish contemporary, J. F. Willumsen.

Later in 1891, Munch started to move towards his own characteristic style of the 1890s, with his painting *Evening*. When it was exhibited in Oslo that autumn, Christian Krohg perceptively wrote: 'Munch is . . . the first one to turn to idealism, who dares to subordinate Nature, his model, to the mood . . . It is related to Symbolism, the latest movement in French art'. The original *Evening* probably no longer exists, but surviving studies for it show use of simplified, flattened forms, and unifying flowing lines. The setting for *Evening* was Åsgårdstrand, a village on the Oslo Fjord, which for many years was Munch's favourite resort, its curving shoreline providing him with a continuous inspiration. Its theme grew from his friend Jappe Nilssen's reaction to an unhappy love affair, and the motif was to recur, with alterations, as *Jealousy* (later renamed *Melancholy*, Plate 21) two years later.

To observe Munch's stylistic development during these three years, we can compare three paintings, all set in Oslo's principal thoroughfare, Karl Johan Street. All are characterized by long, steep perspectives, but there the likeness ends. *Military Band on Karl Johan Street* (1889, Plate 11) is a straightforward impression, somewhat recalling Manet. *Spring Day on Karl Johan Street* (Plate 12) creates its atmosphere of bright sunlight with the air of Impressionism, but with a more loosely pointillist technique. But *Evening on Karl Johan Street* (Plate 13), usually dated 1892, is a mood-painting about fear, the fear of a crowd of people as the sun goes down. It is painted in his new, simplified style, and points forward to other fear subjects in the *Life Frieze*.

Munch returned home from his French studies in March 1892. During the summer he worked in Norway, and that autumn he organized a retrospective exhibition in Oslo to present his work of the past three years, although also including some earlier paintings. The reception was generally bad. The new mood-paintings, with their loose, impressionistic finish, both angered the critics and disappointed many of his supporters among the naturalistic painters. Only a small minority admired his new direction. One

who liked the exhibition was Adelsteen Normann, a Norwegian landscape painter living in Germany, who was on the exhibition committee of the Berlin Artists' Association. He invited Munch to mount an exhibition in Berlin, and the artist immediately accepted this singular opportunity.

The Germans respected nineteenth-century Nordic culture, and Norwegian painters like J. C. Dahl and Hans Gude had established big reputations there. In 1891, four works by Munch had been included in a selection of Norwegian paintings exhibited in Munich, and a critic had written: 'It won't be long before Germany is talking about Scandinavian art instead of French'. Nevertheless it is still surprising that the conservative dominated Berlin Artists' Association should have invited a young radical like Munch to hold a one-man exhibition in a city where Impressionism was still unacceptable. It is much less surprising that a storm broke in the Association when he hung his fifty-five pictures, and that they were removed a week later. However, some members, including Professor Köpping and Max Liebermann, protested that a guest must have freedom of expression; they formed an opposition group within the Association, and reverberations of the affair continued for some time. But although they supported Munch on principle, they did not really appreciate his work, and only Walter Leistikow, a painter of atmospheric landscapes, actually wrote supporting his art. However the affair was widely reported and Munch's status changed overnight from that of a struggling young painter in a small country to a notorious revolutionary in a large one. The progressive dealer Eduard Schulte arranged exhibitions for him in Düsseldorf and Cologne, and in late December Munch opened another exhibition in Berlin.

The exhibitions of 1892 enabled the artist to see the interrelation of many of his paintings and made him consider how best to make the public understand them. In March 1893, he wrote to the Danish painter Johan Rohde: 'At the moment I am occupied with studies for a series of paintings . . . I believe that these . . . will be easier to understand when they are all together. It (the series) will have love and death as its subject matter'. And in the 1930s he looked back: 'When they (the paintings) are shown together they strike a chord; they become quite different than when they are shown by themselves. They become a symphony. That is how I began to paint friezes'. This, then, was the beginning of the *Life Frieze,* paintings based on his subjective psychological experiences and universalized into statements about the soul of modern man. Its original core was a series entitled *Love,* consisting of six paintings, exhibited in Berlin late in 1893. It was expanded during the 1890s, and in 1902 he grouped twenty-two *Life Frieze* paintings together at his important Berlin Secession exhibition. Subsequently it was shown together on several occasions. The general theme remained constant, and some paintings were always included, but Munch from time to time varied other titles. He would always have liked to achieve a permanent public setting for the collected frieze, but this was not accomplished during his lifetime. However, in the home which he finally established in Norway, he retained a collection of the paintings, making new versions of ones which had been sold. When he exhibited the *Life Frieze* together in Oslo, in 1918, he wrote:

'The frieze is intended as a series of decorative pictures, which together give a picture of life. Through it runs the curving shoreline, beyond lies the ocean, . . . and beneath the leafy trees manifold life with its joys and sorrows is lived.

'The frieze is intended to be a poem on life, love, and death'.

During 1893, spent mainly in Germany, Munch completed the original *Love* series. The story can be deduced from the paintings. The girl waits for love in the summer night. Love fuses woman with man in a kiss. The pressure of woman's love causes the man pain. She, however, achieves ecstatic fulfilment. But the climax is followed by jealousy, and love

finally disappears in terrifying despair.

Munch made a number of versions of the motifs; a selection is reproduced here. The titles used today are frequently different from the original ones; the present titles, with the 1893 titles in brackets, are as follows: *The Voice* (*A Summer Night's Dream*, Plate 18); *The Kiss* (*Kiss*, Plate 19); *Vampire* (*Love and Pain*, Plate 20); *Madonna* (*The Face of a Madonna*, Plates 22, 23); *Melancholy* (*Jealousy*, Plates 21, 29); *The Scream* (*Despair*, Plate 24).

The motifs were drawn from his personal memories, some developed from earlier paintings. Thus *The Voice* is an extension of *Puberty* (Plate 8), while we have seen the genesis of *Melancholy* in *Evening*, although the basic theme of a lonely figure on the shore reaches back to *Summer Night. (Inger on the Shore)* (Plate 10), and beyond. Munch was haunted by the thought that love and death were mutually dependent, and his *Madonna's* ecstatic smile as she reaches fulfilment has something corpse-like in it. In the lithographic version (Plate 23), he amplifies this thought by surrounding the figure with a framing design of sperm, while a skeleton-like embryo crouches in the corner. In *The Scream* Munch totally communicates his own schizoid fears, and he re-creates a sunset which to him became coagulated blood, as he 'felt a loud, unending scream piercing nature'. In this apocalyptic scene, where the swirling lines become acoustic reverberations of the scream, he has made a unique visual image of panic.

A few people in Germany could appreciate this kind of painting. Böcklin and Klinger had already established an art of inward-looking Symbolism, albeit in a realistic idiom; indeed Klinger had produced his own pessimistic series of etchings entitled *A Love* in 1887. In 1894 the first book on Munch appeared, containing essays by members of the Scandinavian-slanted intellectual Bohemian circle in Berlin, which congregated at the Black Pig tavern. At its centre were August Strindberg, the Polish writer Stanislaw Przybyszewski, and the German poet Richard Dehmel. The attractive Norwegian *femme fatale* Dagny Juell, who married Przybyszewski and features in Munch's paintings, acted as their exotic muse. From within this circle Julius Meier-Graefe started the important periodical *Pan*. Munch was their leading artist; the Finn, Akseli Gallen-Kallela (who shared an exhibition with Munch), and the Norwegian sculptor, Gustav Vigeland, were also associates. Strindberg, Przybyszewski, and Munch shared many ideas on the psychology of man, the destructive powers of woman, and the superhuman forces, and the artist was clearly at home in this brilliant but over-heated milieu.

Munch's *Life Frieze* subjects, whether inspired by earlier memories or by events in Berlin, typified attitudes held in the Black Pig circle. His powerful idiom of the 1890s, with its swirling lines and bold areas of sonorous colours, expressed uniquely his subjective dramas. *Death in the Sick-Room* (Plate 16) depicts, in the simplified, concentrated new style, the impact of death in his own family. In *The Storm* (Plate 17), turbulence of the elements and of the brush-strokes symbolize the fears of the white-clad figure and the group, from which she is typically isolated. In the painting *Jealousy*, dating from 1894–5 (Plate 26), he uses a new motif to make more explicit the emotion portrayed earlier, in the *Love* series.

In Berlin, Munch also turned to graphic art, thus gaining opportunities for realizing his themes in new forms. Printmaking would allow him to give his artistic ideas wide circulation, and still to retain copies. His first dated engravings are from 1894, and for some time he was to keep to black and white. He worked first with etching or dry-point, which show his delicate line drawing to great advantage, and then proceeded to combine these techniques with aquatint to achieve subtle tonal values. With these his style remained realistic or impressionistic, as with the earlier paintings. Lithographs soon followed, and here Munch became more adventurous. Lithography invited broad handling, with strong contrasts between sweeping lines and heavy black washes, and it

8

was suitable for large-scale work. Thus he found a graphic medium able to parallel the increasingly simplified designs of his paintings of the middle and later 1890s. During 1895 his prints were exhibited for the first time in Berlin, and also offered for sale in Paris.

Although living in Germany, Munch had continued to spend some time in Norway, and in October 1895 he staged another exhibition in Oslo. But apart from his few supporters (and apparently an interest shown by the elderly Ibsen, always Munch's favourite playwright), opinion remained hostile there. Critics found the *Love* series 'visions of a sick brain'. The naturalistic painter Erik Werenskiold (a previous supporter), while admiring the relatively realistic *Self-portrait with a Cigarette* (Plate 1), wrote damningly: 'One can trace no development in his work during the last ten years. . . . Now everything is German philosophy, vampires, women sucking men's blood, love and death etc. And that sort of philosophy does not impress me'. Thadée Natanson, editor of the French periodical *La Revue Blanche*, was also in Oslo and reviewed the exhibition. While feeling that Munch showed rather too many 'metaphysical speculations', like German art, he showed an interest, recommending that the artist should come to Paris, and reproducing the lithograph *The Scream* in his magazine. The artist had re-visited Paris earlier that year and now resolved on a longer stay.

Munch arrived there early in 1896, to stay nearly a year and a half. Here he became part of a milieu not unlike the Berlin one, indeed several of those members had now moved to Paris. It included Gauguin's friends William Molard, and his Swedish sculptor wife Ida Erikson, the composer Delius, and Strindberg, as well as some old Norwegian friends, and he made new contacts in the Symbolist world. Paris, like Germany, was experiencing a phase of interest in Scandinavia, and Munch's commissions included programme designs for Lugné-Pöe's Ibsen productions at the *Théâtre de l'Oeuvre*. He made a portrait of Mallarmé, and designed illustrations for Baudelaire's *Les Fleurs du Mal*.

But the period's greatest importance was in Munch's development as a printmaker. He was able to collaborate with the most inventive graphic technicians of the day, Clot and Lemercier. He saw Japanese woodcuts, and prints by outstanding modern artists like Bonnard, Gauguin, Toulouse-Lautrec, and Vallotton. Munch now began to print in colour, a field where for originality and beauty he has remained unsurpassed. In 1896 he made his famous lithograph *The Sick Child* (Plate 7), printed in different beautiful colour combinations by Auguste Clot. Here the delicate drawing keeps close to the painting of ten years before, but usually his colour lithographs are closer to his newer paintings. Sometimes his colour experiments with a print spread over many years. Both *Madonna* (Plate 23) and *Vampire* (Plate 20) started as single-colour lithographs in 1895, and only received their final colour in 1902. In the latter case the artist achieved a particularly rich texture by combining lithograph with woodcut.

Munch's woodcuts are the most individual of all his prints. The first of these, *Fear* (Plate 25), made in 1896, derived through a painting and a colour lithograph, combines motifs from *The Scream* (Plate 24) and *Evening on Karl Johan Street* (Plate 13). The mood of foreboding in the white faces is also apparent in *Moonlight* (Plate 28), but the artist now used colour more subtly. Here Munch employed what was to become a favourite device, sawing the block into several pieces to be inked separately, then re-assembled and printed together. He thus produced a multi-coloured print with an even grain. He also does this in *Melancholy* (Plate 29), developed from the painting *Evening*, of 1891. Because of this ceaseless experimenting, Munch's coloured print subjects frequently occur in many variations of colour and texture.

While in Paris, Munch also exhibited his works, twice at the Salon des Indépendants, where he showed a selection from the *Life Frieze* and once at Bing's gallery, *L'Art Nouveau*,

where his friend Meier-Graefe now worked. Strindberg wrote about him in *La Revue Blanche,* and a few critics showed some understanding, notably Edouard Gérard in *La Presse,* who compared his work to Maeterlinck's dramas. Munch must have regarded this stay in Paris as encouraging, and he later expressed gratitude that some appreciation had been shown of the *Life Frieze* pictures.

On leaving Paris, Munch returned home, buying a cottage in Åsgårdstrand. But although he now remained based in Norway for some years, he still travelled vigorously, now including Italy in his visits. Italian Renaissance art probably encouraged his own endeavours towards monumental painting; he admired Michelangelo, in particular the Sistine Chapel. One reason for this restless travelling was his wish to escape from a wealthy young woman, who was as determined to marry Munch as he was to remain single. She pursued him remorselessly, threatening his stability, and thus further encouraging his heavy dependence on alcohol. For a time he entered a sanatorium, but on his emergence the pursuit continued. The affair ended in a fake suicide attempt at Åsgårdstrand, and an accidental pistol shot which robbed Munch of part of a finger, a wound he never forgot.

Despite these interruptions, the artist continued to find new *Life Frieze* type subjects. *Mother and Daughter* (Plate 27) shows the isolation of youth from age. *Melancholy (Laura)* (Plate 30), based on his unhappy sister, depicts the most extreme form of isolation – that of losing one's reason. The woman sits gazing at nothing, trapped in her corner by the threatening patterns of the blood-red tablecloth. In *The Dance of Life* (Plate 32) he develops a favourite theme, his three archetypes of woman. The virgin reaches out towards life, the sensual, red-clothed woman lives it with her partner, while fulfilment has eluded the faded woman on the right. But during the mid-1890s he had also started to set down themes hinting at the more extrovert philosophy which was to be the basis for the Oslo University murals. Around the turn of the century he introduced more objectively-seen motifs and a less pessimistic viewpoint in a number of works. *Girls on the Jetty* (Plate 34) conveys the peaceful atmosphere of a summer evening, and *The Dance on the Shore* (Plate 33), while including the three female types of *The Dance of Life,* has become a midsummer idyll rather than a symbolic statement. Munch now turned again to pure landscapes, producing such atmospheric evocations of the Norwegian scenery as *Winter* (Plate 31), and *White Night* (Plate 35). In prints he continued to develop coloured versions of earlier subjects, and also to introduce new themes; the woodcuts were still particularly notable.

In Norway, Munch's main work was still far from acceptance, and although between 1897 and 1901 the National Gallery purchased five paintings, they were all uncontroversial ones. But in 1902 came his real breakthrough in Germany. He was invited to make a major contribution to an exhibition of the Berlin Secession, where some of his old friends were now influential. Here he assembled twenty-two of his *Life Frieze* paintings, and they were recognized as original and important. Now success came quickly. Important exhibitions followed in Vienna and Prague, contracts were concluded in Germany with the dealers Bruno Cassirer and Commeter, and within a few years Munch became a major international name east of the Rhine. His work started to influence younger artists in Germany, particularly the Expressionists of *Die Brücke,* and Czechoslovakia. This recognition contrasted with his feelings about Norway. The brutal conclusion of the 'finger affair' caused a break with a number of friends who had been involved. The feeling that Norwegians were persecuting him intensified his insecurity and drinking, and he responded with virulent caricatures and became involved in several brawls. Consequently until 1908 he lived increasingly in Germany and even considered settling there permanently. In Germany, he attracted new patrons, who became firm

friends, buying his work and trying to help him manage his life. Such were Dr. Max Linde, the Lübeck art connoisseur, the mysterious and wealthy Albert Kollman, the Chemnitz industrialist Herbert Esche, and Gustav Schiefler, the cataloguer of Munch's prints. There was also Count Harry Kessler and the Nietzsche circle in Weimar, and Max Reinhardt, who commissioned stage designs for Ibsen's *Ghosts* and a decorative frieze for his Berlin theatre. Yet difficulties in maintaining the uneasy equilibrium of his life remained, and he wrote to Jens Thiis, one of his most constant Norwegian supporters: 'My fame is increasing, but happiness is another thing'.

After 1900, Munch turned increasingly to nature for new motifs; and this was encouraged by his commissions. He discovered new interest in painting children, which he did very successfully, as in the sophisticated group portrait of Dr. Linde's sons (Plate 36). Dr. Linde also commissioned a frieze of paintings for the children's room in his home, but despite Munch's attempts to keep the motifs happy and uncomplicated, the doctor did not consider the results suitable, compensating the artist with an alternative purchase. Munch's portraits of adults during this period are also strong, as is the one of Walter Rathenau, his earliest German patron (Plate 37).

In these new subjects, Munch gradually adopted a more brilliant range of colours, and moved from the flat patterns and swirling lines of the 1890s towards a freer, more broken surface. He wrote: 'I had the urge to break areas and lines . . . I felt that this way of painting might become a manner . . . Afterwards I painted a series of pictures with pronounced, broad lines or stripes, often a metre in length, running vertically, horizontally or diagonally'. It is as if Munch had decided to extend some of the pointillist tendencies in his paintings of 1891, but using stripes instead of irregular dots, and adopting more rectilinear forms. The idea of stripes may have been suggested by the gouged striations of his woodcuts. These experiments were most radical for the few years from 1907 on; and they dominate the *Death of Marat* (Plate 38), a summing up of his feelings of the murderous possessiveness of woman, engendered by the affair of 1902. In the same year he started his heroic *Men Bathing* (Plate 39), the centrepiece of a triptych describing the three ages of man. Progressing from studies of bathing boys from the 1890s, it forms an assertive male complement to his three stages of woman.

Munch's 'nerve-crisis' finally ended in a severe breakdown in 1908, in Copenhagen, and until May 1909 he underwent treatment there at Dr. Daniel Jacobson's clinic. He saw the breakdown as the conclusion of a period in his life, and he committed all his will-power to recovering: 'It was in quite a brutal way that I finally made the decision to restore myself. . . . let us hope that this is the beginning of a new era of my art'. He wrote ironically to a friend: 'I've joined the Order "Don't Indulge" – cigars without nicotine – drinks without alcohol – women without sex' (he was to remain an almost total abstainer from alcohol). While under treatment, Munch continued to work. He drew animals in the zoo and, following his doctor's advice, externalized his fears of woman in the series of lithographs *Alpha and Omega*. This bitter tragi-comedy constituted his last new statement on the theme. He produced several fine portraits, including that of Dr. Jacobson, and one of himself, in his experimental style (Plate 2). If the 1895 *Self-portrait with a Cigarette* (Plate 1) showed a fear-haunted visionary, this one reveals a fighter who has won his battles and looks ahead with determination.

While he was in Copenhagen, events in Norway were moving in his favour. In 1908 Jens Thiis became director of the National Gallery, purchasing five major works, and Munch was made a knight of the Royal Norwegian Order of St. Olav. Early the following year Thiis and Jappe Nilssen arranged a large exhibition of his paintings and prints, which was a public success. It now became possible for such friends to reassure Munch

that he should return to Norway, and this he did on his recovery. Back at home, the artist settled in the small south-coast town of Kragerø, and although he acquired additional properties to give himself more working space, this remained a base for six relatively harmonious years. There he started to work on designs for the competition for the Oslo University murals.

The University murals provided the long-sought opportunity to create a monumental series of paintings for a permanent setting. The small scale Linde and Reinhardt friezes must have whetted Munch's appetite, but the University project demanded a much more ambitious and majestic solution. Munch wished to create a comprehensible modern classic, both Norwegian and universal, suitable for the new neo-classical hall in Norway's senior academic institution. The theme he chose, of mankind as a harmonious part of nature, was a logical outcome of his search for a new harmony, a complement to the *Life Frieze*. In his own words: 'In respect of their content of ideas the two must be looked upon as a single whole: the *Frieze of Life* presents the sufferings and joys of the individual as seen from close at hand – the University murals show the great eternal forces'. Some of the ideas were developments from motifs of the later 1890s, while others carried on from more recent works, such as *Men Bathing* (Plate 39). Some themes were explored first in new individual pictures, as with *Life* (Plate 40).

The general background of the murals is the southern coast of Norway. Three large paintings each dominate a wall: *The Sun* (Plate 41), *History*, where an old man instructs a small boy, and *Alma Mater*, symbolizing both motherhood and the University. In between, linking them, are related smaller paintings illustrating mankind's activities and researches in nature, their subsidiary role emphasized by lighter treatment. The most remarkable conception is the centrepiece, *The Sun*. Originally Munch had considered the Nietzschean idea of a mountain of men, struggling towards the sun's light, but the idea was disliked by the selecting authorities. His final solution, therefore, became the sun itself, bursting up over the coast at Kragerø, its iridescent rays giving energy to the nude figures on the adjoining panels and establishing the keynote for the whole hall.

It is a period when many Nordic artists, for example J.F. Willumsen and Gustav Vigeland, aspired to monumental projects on similar themes of life forces. Among these, Munch's University murals are outstanding, even if, with the exception of *The Sun*, the demands of a public art led him to more conventional solutions than in his most imaginative work. Nevertheless it took two competitions, and several years of wrangling, before the pressure of Munch's supporters and weight of his European reputation persuaded the University to accept them. With their unveiling in 1916 the artist had finally won his position in Norway.

The ten years after Munch's homecoming were also exceptionally rich in other works. His technical experiments had now crystallized into rythmically strong, fluent painting, in brilliant colours. He also introduced this new colour range in his woodcuts with bold ingenuity, as in *Sunbathing (Woman on the Rock)* (Plate 42), a theme related to the University murals. His thoughts on a public art were now fully aroused: 'Perhaps art once again will become the property of everyone as it was in the olden days – it will appear in public buildings and even on the streets'. Probably Munch's aspirations in this direction encouraged the frequent choice of large format, and possibly also his concentration on extrovert subjects, although in his new life he was also careful not to dwell too much on dangerous past obsessions. He now explored the theme of working life, a territory which he had only occasionally touched on previously. In these new motifs he emphasizes both the dignity and strength of labour, usually presenting the figures frontally, moving towards the viewer, as in *Workmen in the Snow* (Plate 43). In the light-filled *Man in a Cabbage*

Field (Plate 44), the labourer's arms sweep up both cabbages and the perspectives of the field into a monumental triangle, as he moves purposefully towards us. With *Horse Team* (Plate 45), the dynamic power is given to the magnificent horses, rather than to the diminutive ploughman who follows them.

In 1916 Munch moved to Ekely, just outside Oslo, which became his final home. He had declared that: 'The only real danger for me is to be unable to work', and Ekely was devoted to avoiding this danger. Almost every room was a working room, outside were open-air studios, and he eventually added a separate large winter studio. Munch increasingly came to regard his paintings as a family, which he needed to have around him. He hardly ever now sold paintings, and he made new versions of ones he no longer possessed, especially if he regarded the themes as belonging to a series. He hoarded old notes and letters, and even toyed with the idea of writing an autobiography. At the same time in the outside world his fame and exhibitions continued to increase. In the 1920s he still made trips abroad, visiting old friends and exhibitions, but from the end of that decade he became increasingly a recluse.

During the 1920s Munch remained prolific. In 1922 he painted appropriately light-weight and charming murals for the canteen of the Freia Chocolate Factory in Oslo, and in 1928 he was asked to suggest decorations for the new Oslo Town Hall, then being planned. He set out some ideas incorporating scenes of working men, with *Workmen in the Snow* (Plate 43) as a centrepiece, but the project hung fire, and by the time building commenced ten years later he was really too old for so major a task. With individual paintings there were many re-workings of old themes, and some new subjects based on past memories. But there were also entirely new motifs, magnificent landscapes like *Starry Night* (Plate 46) (usually associated with Ibsen's play *John Gabriel Borkman*), or paintings where he could still respond to the beauty of light and colour on a woman's body, as in *Nude by the Wicker Chair* (Plate 47). Ibsen's plays were also important for his print subjects. He added new lithographs to earlier motifs drawn from *Ghosts*, and made a series of woodcuts based on *The Pretenders*. A model whom he used in connection with that series, also inspired the woodcut *Gothic Maiden* (Plate 48), a beautiful blend of expressive drawing and abstract texture.

Eye trouble placed some restrictions on Munch during the 1930s, and his work shows more uneven quality. But his mastery could still assert itself, as in several remarkable self-portraits painted in the last years of his life. In *Self-portrait between the Clock and the Bed* (Plate 3), he sees himself with composed irony, the pathos of the 'lean and slippered pantaloon' of old age contrasted with the cheerful colours and the nude study above the bed.

Munch had always been grateful to Germany, but rupture occurred in 1937 when the Nazis declared his art to be degenerate, and removed his paintings from German museums. When Norway was occupied in 1940, he was naturally apprehensive. However, although he refused to have any contact with either German invaders or Norwegian Quislings, Munch remained unmolested, and died peacefully at his home in January 1944. He had just completed a new version of the lithographic portrait of his old friend Hans Jaeger, long since dead. It seems fitting that the artist's last work should recall him. No one of the Oslo Bohemians of the 1880s had more thoroughly fulfilled Jaeger's first principle: 'You must write about your own experiences'.

Select Bibliography

A detailed bibliography is contained in the publication by H. B. Muller.

Benesch, Otto, *Edvard Munch*. London, 1960.

Boulton Smith, J., *Portrait of a Friendship: Edvard Munch and Frederick Delius*. In *Apollo*, January 1966. London.

Deknatel, Frederick B., *Edvard Munch*. New York, 1950.

Glaser, Kurt, *Edvard Munch*. Berlin, 1917. (New edition 1922).

Heller, Reinhold, *Edvard Munch: The Scream*. London, 1973.

Hodin, J.P., *Edvard Munch*. London, 1972.

Langaard, Ingrid, *Edvard Munch. Modningsår*. Oslo, 1960

Langaard, Johan H. and Revold, Reidar, *The Drawings of Edvard Munch*. Oslo, 1958; *Edvard Munch. A Year by Year Record of Edvard Munch's Life*. Oslo, 1961; *Edvard Munch: The University Murals*. Oslo, 1961; *Edvard Munch. Masterpieces from the Artist's Collection in the Munch Museum in Oslo*. Oslo, 1964.

Muller, H.B., *Edvard Munch. A Bibliography. Oslo Kommunes Kunstsamlinger Årbok 1946–1951*. Oslo, 1951. Supplement in *Oslo Kommunes Kunstsamlinger Årbok 1952–1959*. Oslo, 1960.

Munch-Museet, *Catalogue 4, 1967*. Oslo, 1967.

Przybyszewski, Stanislaw; Meier-Graefe, Julius; Pastor, Willi; Servaes, Franz., *Das Werk des Edvard Munch*. Berlin, 1894.

Schiefler, Gustav, *Verzeichnis des graphischen Werks Edvard Munchs bis 1906*. Berlin, 1907; *Edvard Munchs graphische Kunst*. Dresden, 1923. *Edvard Munch, das graphische Werk, 1906–26*. Berlin, 1928.

Stang, Nic, *Edvard Munch*. Oslo, 1972.

Stenersen, Rolf, *Edvard Munch: Close-up of a Genius*. Oslo, 1969.

Thiis, Jens, *Edvard Munch og hans samtid*. Oslo, 1933.

Timm, Werner, *The Graphic Art of Edvard Munch*. London, 1969.

Outline Biography

1863 Born in Løten, Norway, 12 December, son of a military doctor. Family move to Oslo (then Christiania) the following year.

1868 Death of his mother.

1877 Death of his sister, aged fifteen.

1881–6 Studies art at School of Design, Oslo, and independently under Christian Krohg and Frits Thaulow.

1885–6 Three-week stay in Paris. Paints *The Sick Child*.

1889–92 First one-man exhibition. Death of his father. Works in Paris with State scholarships. Studies with Léon Bonnat.

1892 Exhibitions in Oslo and Berlin. Opposition to his work closes the latter and makes his name known in Germany.

1892–5 Lives mainly in Berlin. Starts *Life Frieze*. Frequents advanced literary and artistic circles associated with the periodical *Pan*. First etchings and lithographs.

1896–7 Mainly in Paris. Starts making woodcuts and coloured prints. Establishes contact with Symbolists, and exhibits.

1897–1901 Based mainly in Norway, especially Åsgårdstrand. Visits Germany, Italy and France.

1902 Breakthrough exhibition in Berlin and important new German patrons. Quarrels with Norwegian colleagues.

1905 Major exhibition in Prague.

1906–8 Lives in Germany. Work for Max Reinhardt's Berlin theatre and with Nietzsche circle in Weimar.

1908–9 Has nervous breakdown in Copenhagen. Honoured in Norway.

1909 Major exhibition in Norway. Returns home to live. Starts designing murals for Oslo University.

1916 Makes Ekely, just outside Oslo, his home. University murals unveiled.

1922 Mural decorations for Freia Chocolate Factory.

1922–7 Works at home, but continues to visit Germany and Paris. Honours and exhibitions in Germany. Subsequently remains in Norway.

1937 Major exhibition in Amsterdam. Works branded as degenerate by the Nazis in Germany.

1944 Dies at Ekely, 12 January. Bequeaths to Oslo the enormous collection of his works still in his possession.

List of Plates

7. *The Sick Child.* 1896. Lithograph, 42·1 × 56·5 cm. Schiefler No. 59. Oslo, Munch-Museet.

8. *Puberty.* 1895. Canvas, 151 × 110 cm. Oslo, Nasjonalgalleriet.

9. *Night in St. Cloud.* 1890. Canvas, 64·5 × 54 cm. Oslo, Nasjonalgalleriet.

10. *Summer Night. (Inger on the Shore).* 1889. Canvas, 126·4 × 161·7 cm. Bergen, Rasmus Meyers Samlinger.

11. *Military Band on Karl Johan Street.* 1889. Canvas, 102 × 141·5 cm. Zürich, Kunsthaus.

12. *Spring Day on Karl Johan Street.* 1891. Canvas, 80 × 100 cm. Bergen, Billedgalleri.

13. *Evening on Karl Johan Street.* 1892. Canvas, 84·5 × 121 cm. Bergen, Rasmus Meyers Samlinger.

14. *Portrait of Hans Jaeger.* 1889. Canvas, 109·5 × 84 cm. Oslo, Nasjonalgalleriet.

15. *Portrait of the Artist's Sister, Inger.* 1892. Canvas, 172 × 122·5 cm. Oslo, Nasjonalgalleriet.

16. *Death in the Sick-Room.* c.1893. Casein on canvas, 150 × 167·5 cm. Oslo, Nasjonalgalleriet.

17. *The Storm.* 1893. Canvas, 98 × 127 cm. Oslo, Private Collection.

18. *The Voice.* c.1894–5. Canvas, 88 × 110 cm. Oslo, Munch-Museet.

19. *The Kiss.* 1892. Canvas, 73 × 92 cm. Oslo, Nasjonalgalleriet.

20. *Vampire.* 1895–1902. Lithograph and woodcut, 38·8 × 55·2 cm. Schiefler No. 34. Oslo, Munch-Museet.

21. *Melancholy.* c.1892–3. Canvas, 64·5 × 96 cm. Oslo, Nasjonalgalleriet.

22. *Madonna.* c.1893. Canvas, 91 × 70·5 cm. Oslo, Nasjonalgalleriet.

23. *Madonna.* 1895–1902. Lithograph, 61 × 44·1 cm. Schiefler No. 33. Oslo, Munch-Museet.

24. *The Scream.* 1893. Oil, pastel, and casein on cardboard, 91 × 73·5 cm. Oslo, Nasjonalgalleriet.

25. *Fear.* 1896. Woodcut, 46 × 37·7 cm. Schiefler No. 62. Oslo, Munch-Museet.

26. *Jealousy.* 1894–5. Canvas, 66·8 × 100 cm. Bergen, Rasmus Meyers Samlinger.

27. *Mother and Daughter.* c.1897. Canvas, 135 × 163 cm. Oslo, Nasjonalgalleriet.

28. *Moonlight.* 1896. Woodcut, 41 × 46·9 cm. Schiefler No. 81. Oslo, Munch-Museet.

29. *Melancholy.* 1896. Woodcut, 37·6 × 45·5 cm. Schiefler No. 82. Oslo, Munch-Museet.

30. *Melancholy. (Laura).* 1899. Canvas, 110 × 126 cm. Oslo, Munch-Museet.

31. *Winter.* 1899. Canvas, 60·5 × 90 cm. Oslo, Nasjonalgalleriet.

32. *The Dance of Life.* 1899–1900. Canvas, 125·5 × 190·5 cm. Oslo, Nasjonalgalleriet.

33. *The Dance on the Shore.* 1900–02. Canvas, 95·5 × 98·5 cm. Prague, Národní Galerie.

34. *Girls on the Jetty.* c.1899–1901. Canvas, 136 × 125·5 cm. Oslo, Nasjonalgalleriet.

35. *White Night.* 1901. Canvas, 115·5 × 110·5 cm. Oslo, Nasjonalgalleriet.

36. *The Four Sons of Dr. Max Linde.* 1903. Canvas, 144 × 199·5 cm. Lübeck, Museum.

37. *Portrait of Walter Rathenau.* 1907. Canvas, 220 × 110 cm. Bergen, Rasmus Meyers Samlinger.

38. *Death of Marat.* 1907. Canvas, 151 × 148 cm. Oslo, Munch-Museet.

39. *Men Bathing.* 1907–8. Canvas, 206 × 227 cm. Helsinki, Ateneumin Taidemuseo.

40. *Life.* 1910. Canvas, 196 × 370 cm. Oslo, Town Hall.

41. *The Sun.* (Central painting of Oslo University murals.) 1909–16. Canvas, 455 × 780 cm. Oslo, University Assembly Hall.

42. *Sunbathing. (Woman on the Rocks).* 1915. Woodcut, 35·1 × 56·6 cm. Schiefler No. 440. Oslo, Munch-Museet.

43. *Workmen in the Snow.* 1912. Canvas, 161 × 195·5 cm. Oslo, Munch-Museet.

44. *Man in a Cabbage Field.* 1916. Canvas, 136 × 181 cm. Oslo, Nasjonalgalleriet.

45. *Horse-team.* 1919. Canvas, 110·5 × 145·5 cm. Oslo, Nasjonalgalleriet.

46. *Starry Night.* 1923–4. Canvas, 120·5 × 100 cm. Oslo, Munch-Museet.

47. *Nude by the Wicker Chair.* 1929. Canvas, 122·5 × 100 cm. Oslo, Munch-Museet.

48. *Gothic Maiden. (Birgitte Prestøe).* 1931. Woodcut, 59·6 × 32·1 cm. Oslo, Munch-Museet.

Note: Small variations in size frequently occur between different impressions of Munch's prints.

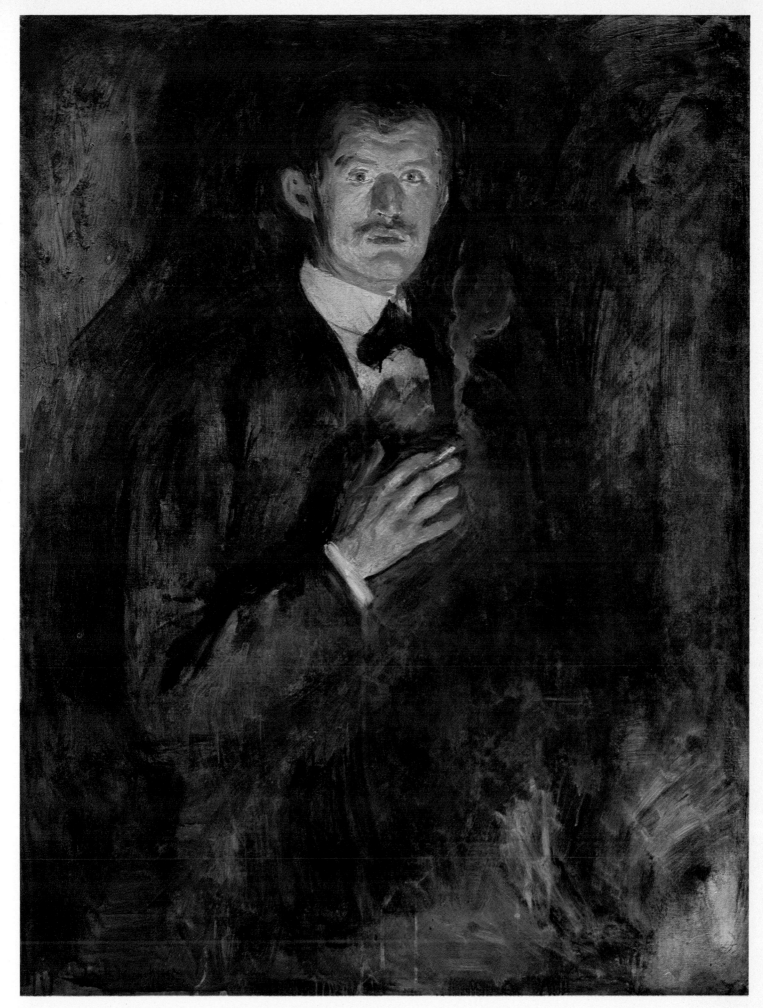

1. *Self-portrait with a Cigarette.* 1895. Oslo, Nasjonalgalleriet

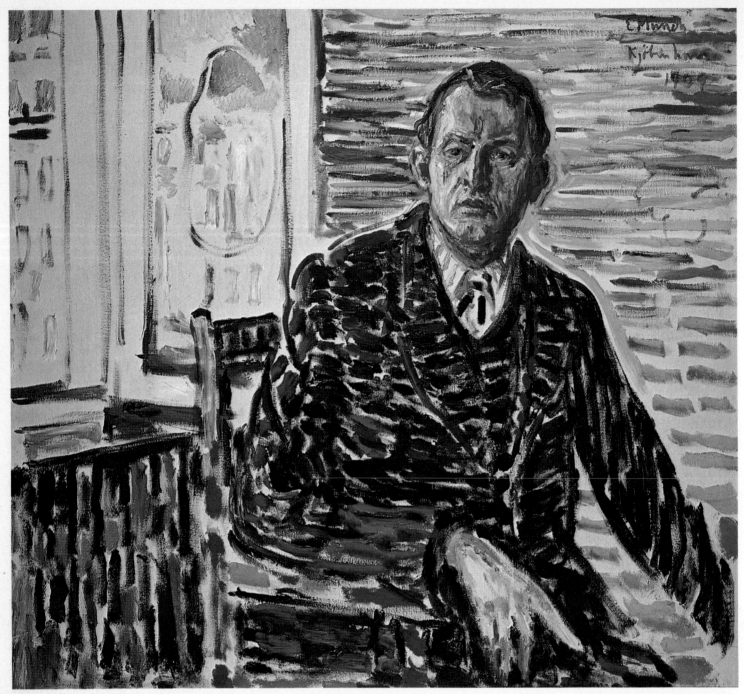

2. *Self-portrait*. 1909. Bergen, Rasmus Meyers Samlinger

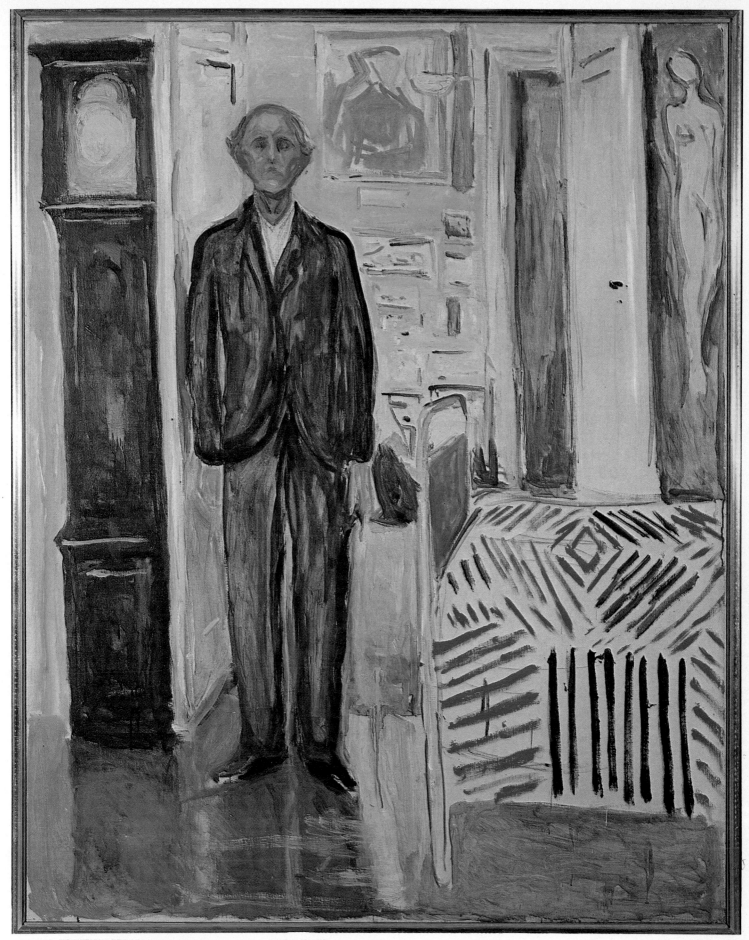

3. *Self-portrait. Between the Clock and the Bed.* 1940–42. Oslo, Munch-Museet

4. *From Maridalen.* 1881. Oslo, Nasjonalgalleriet

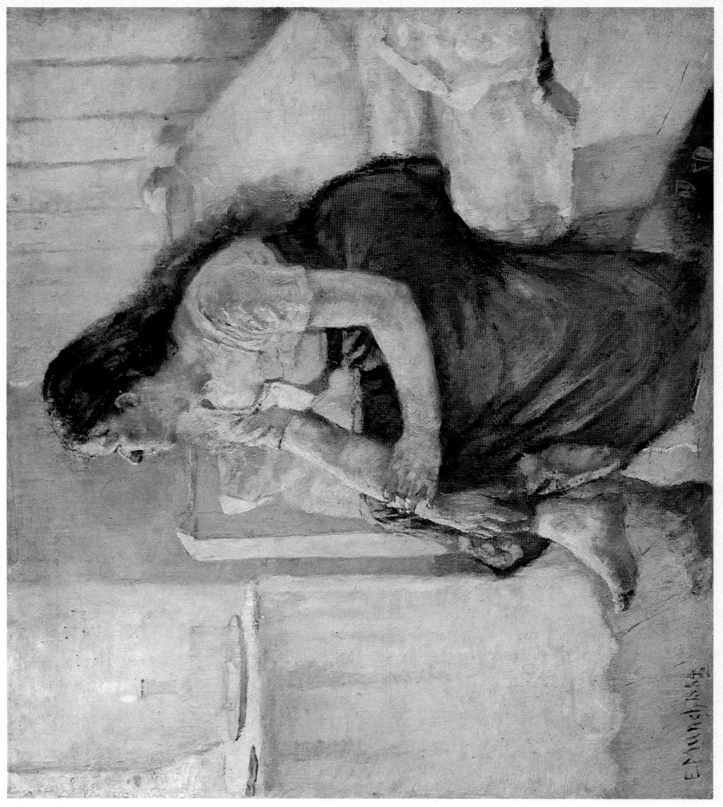

5. *Girl on the Edge of the Bed.* 1884. Bergen, Rasmus Meyers Samlinger

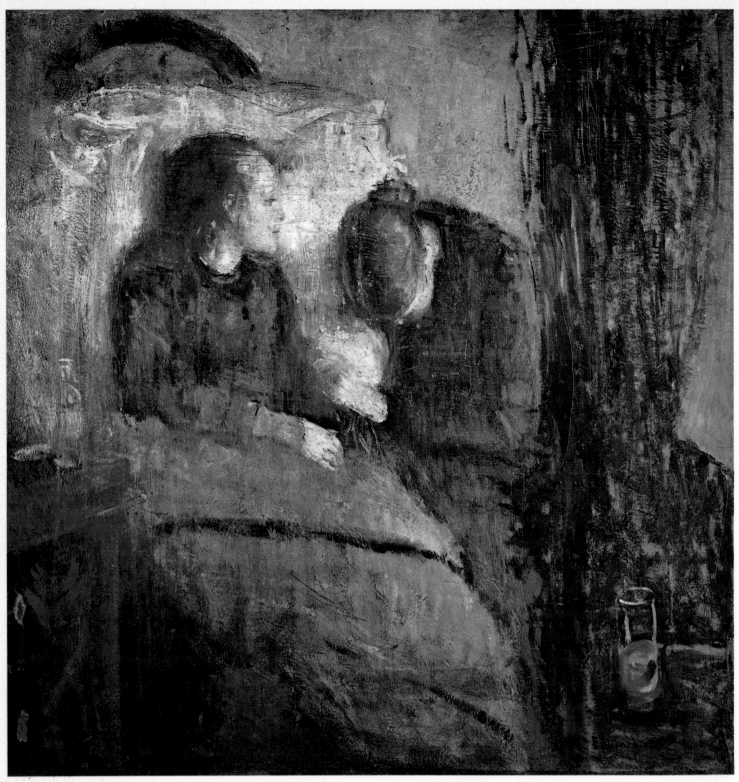

6. *The Sick Child*. 1885–6. Oslo, Nasjonalgalleriet

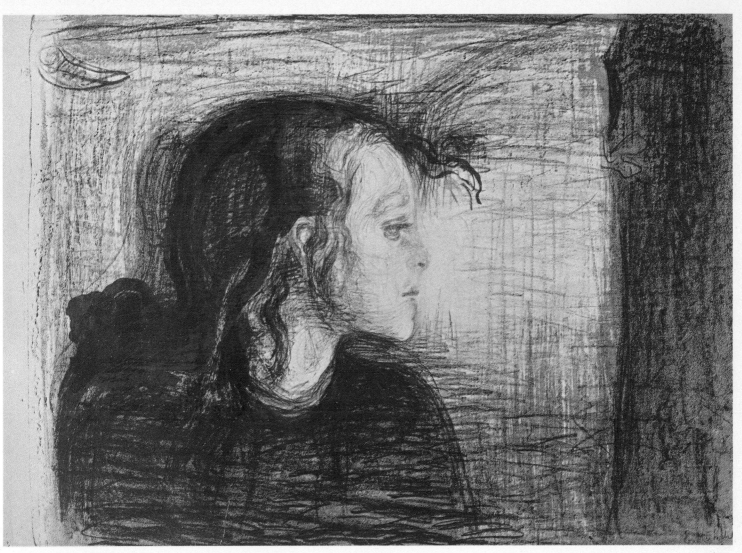

7. *The Sick Child*. 1896. Oslo, Munch-Museet

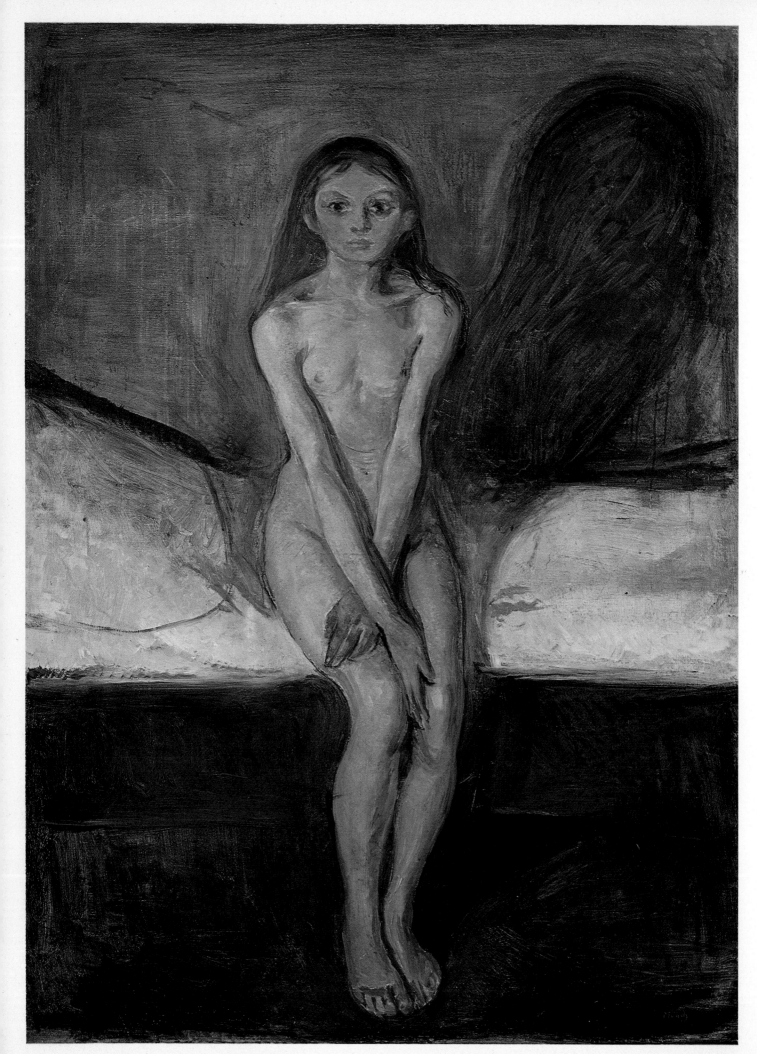

8. *Puberty*. 1895. Oslo, Nasjonalgalleriet

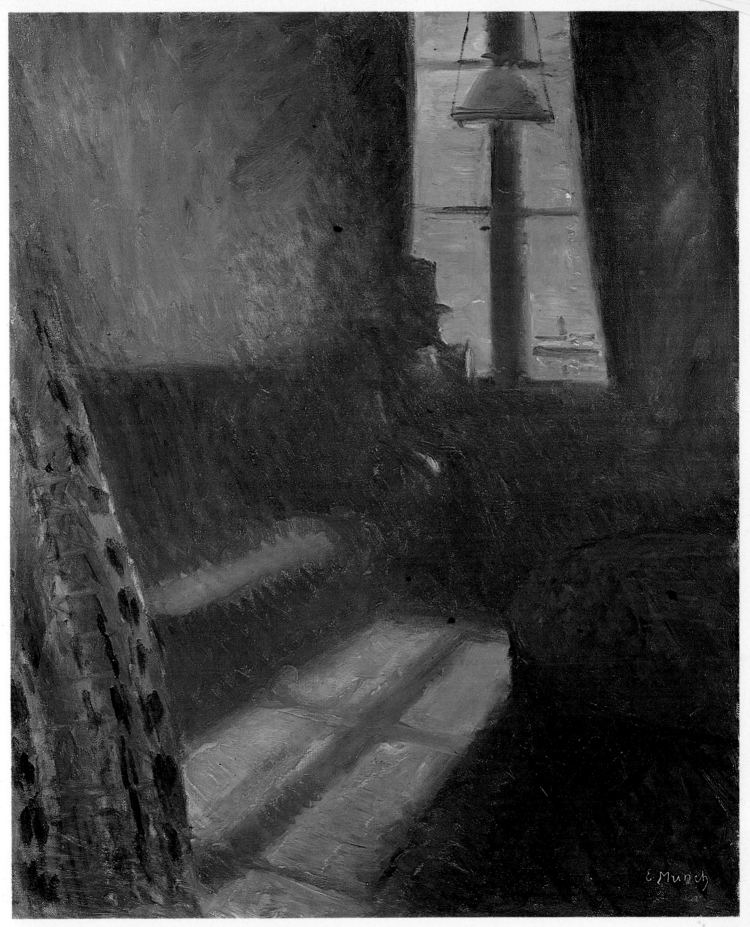

9. *Night in St. Cloud.* 1890. Oslo, Nasjonalgalleriet

10. *Summer Night. (Inger on the Shore).* 1889. Bergen, Rasmus Meyers Samlinger

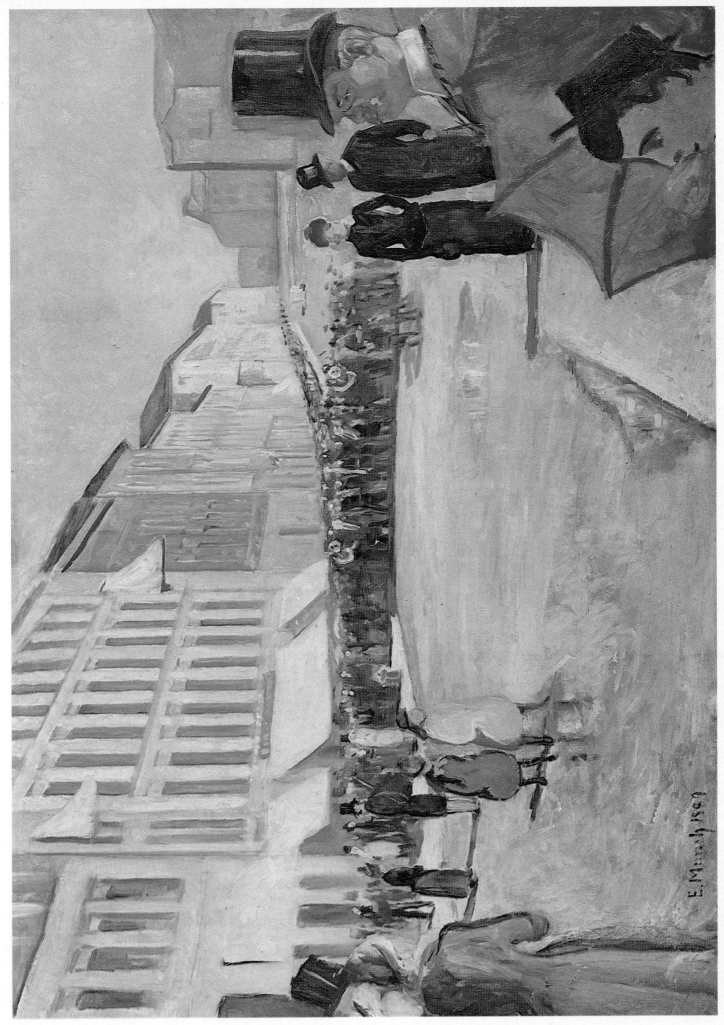

11. *Military Band on Karl Johan Street.* 1889. Zürich, Kunsthaus

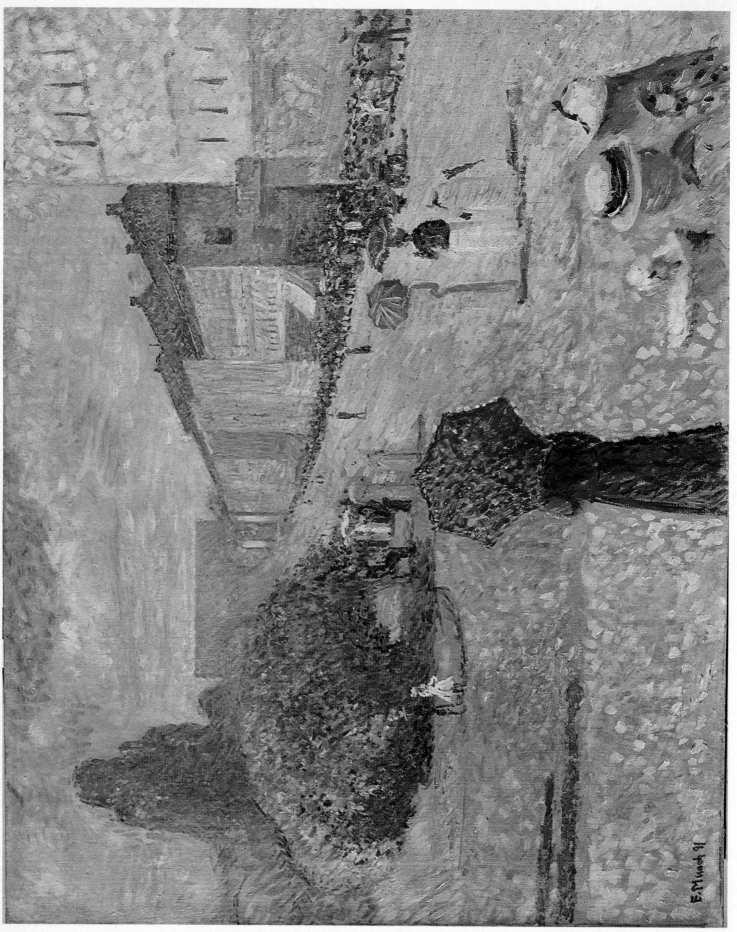

12. *Spring Day on Karl Johan Street.* 1891. Bergen, Billedgalleri

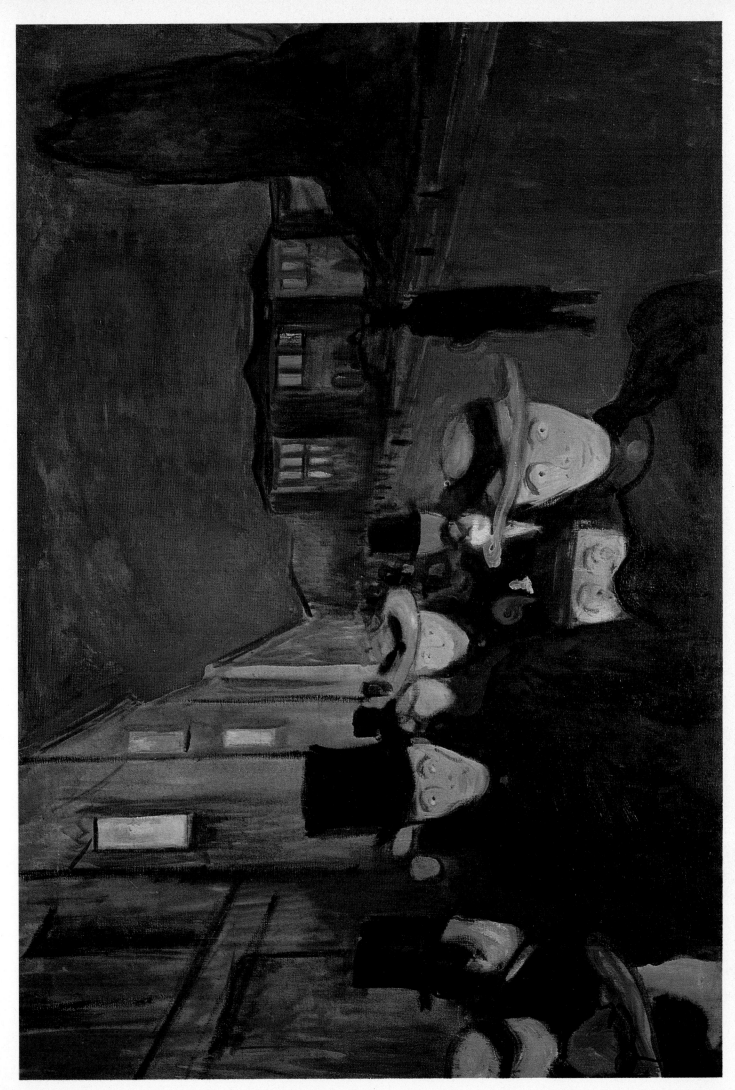

13. *Evening on Karl Johan Street.* 1892. Bergen, Rasmus Meyers Samlinger

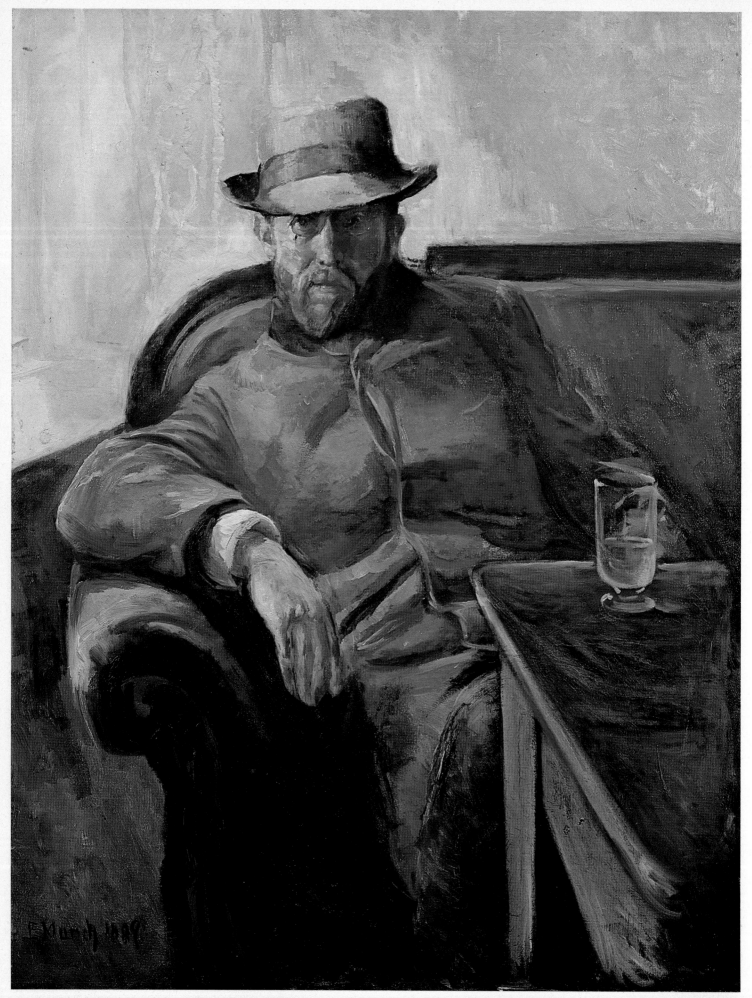

14. *Portrait of Hans Jaeger*. 1889. Oslo, Nasjonalgalleriet

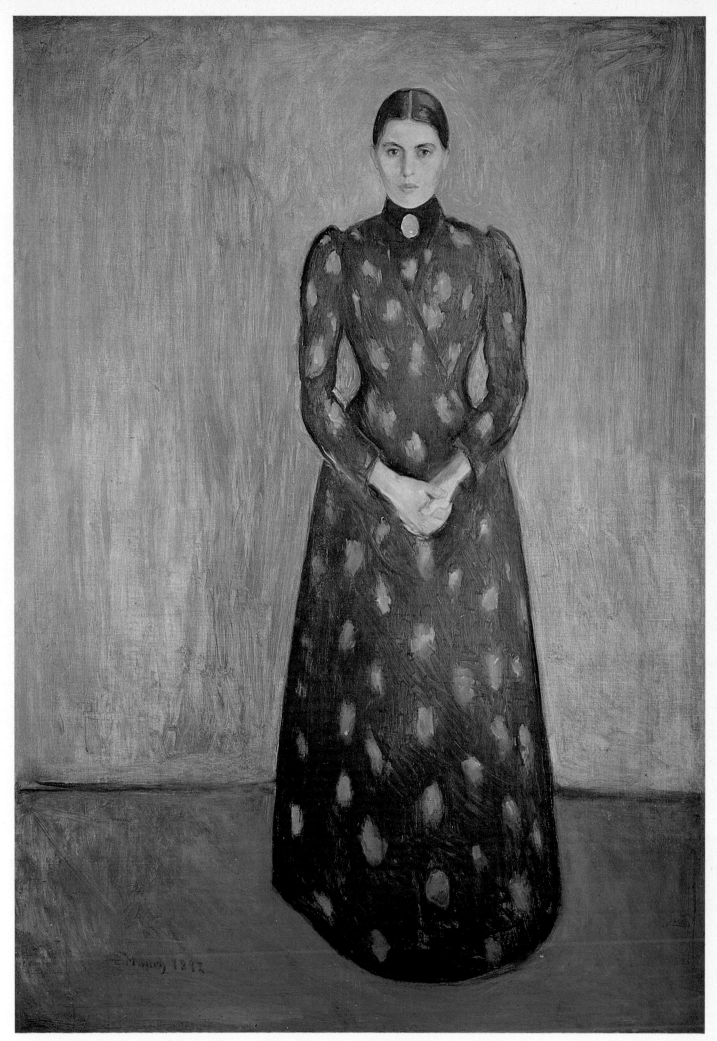

15. *Portrait of the Artist's Sister, Inger.* 1892. Oslo, Nasjonalgalleriet

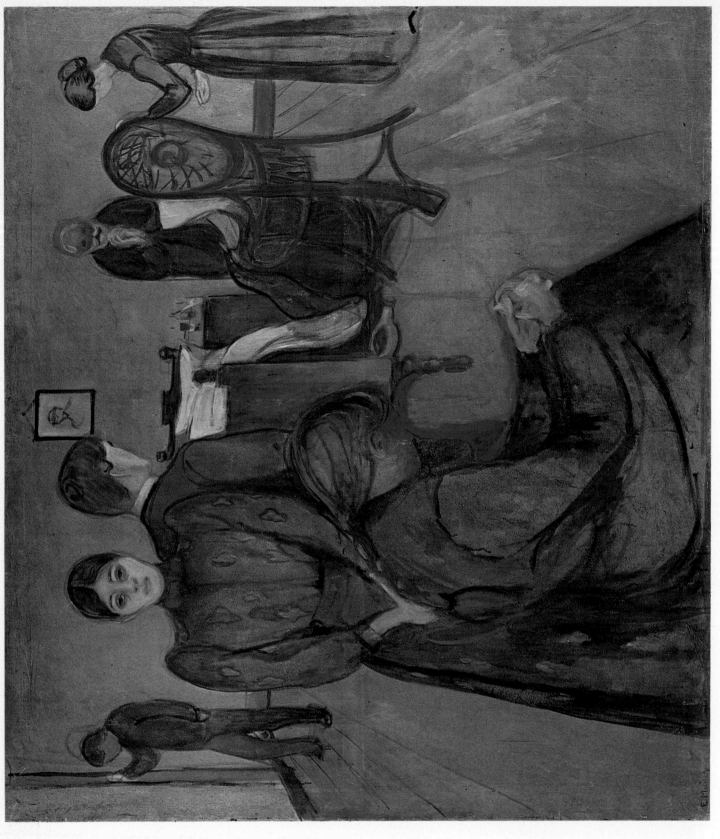

16. *Death in the Sick-Room.* c.1893. Oslo, Nasjonalgalleriet

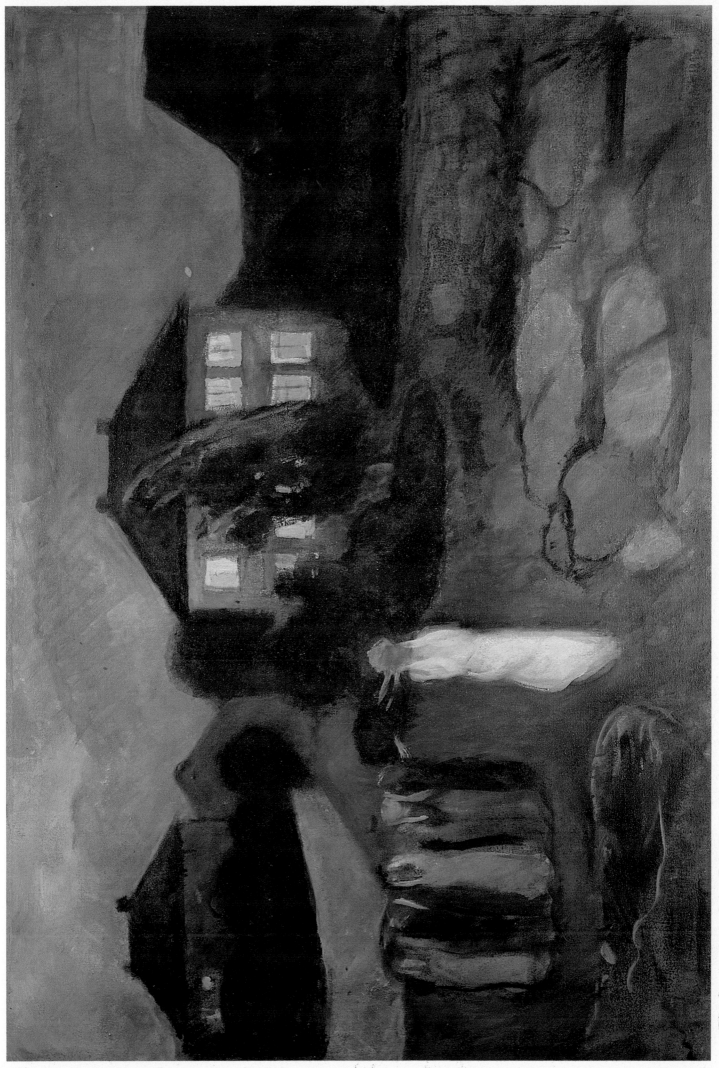

17. *The Storm.* 1893. Oslo, Private Collection

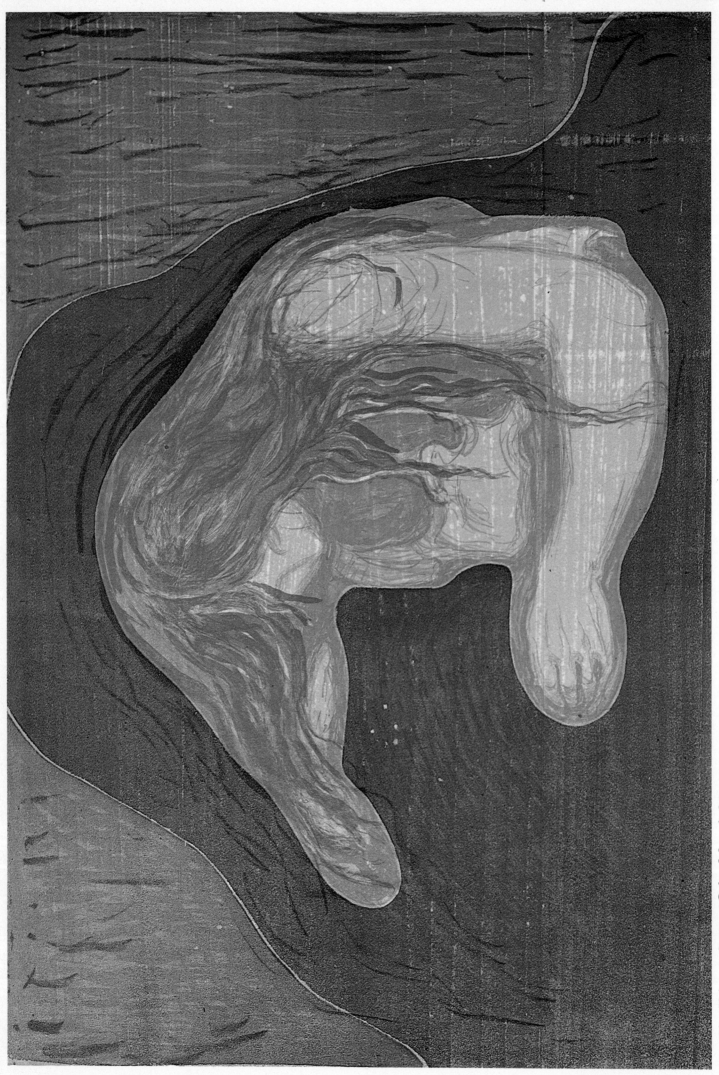

18. *The Voice. c.*1894–5. Oslo, Munch-Museet

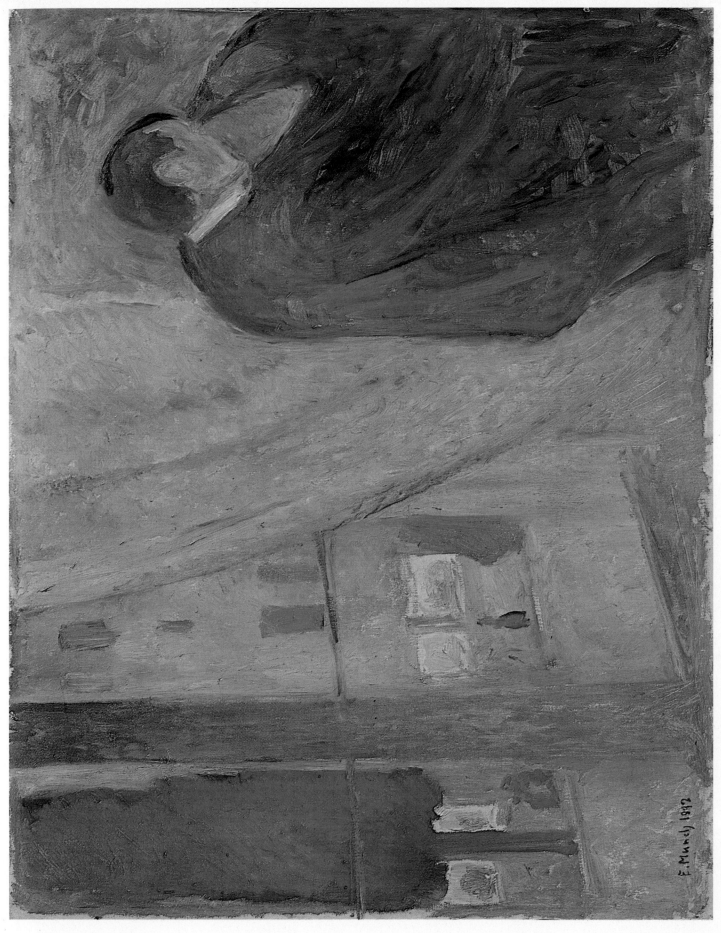

19. *The Kiss.* 1892. Oslo, Nasjonalgalleriet

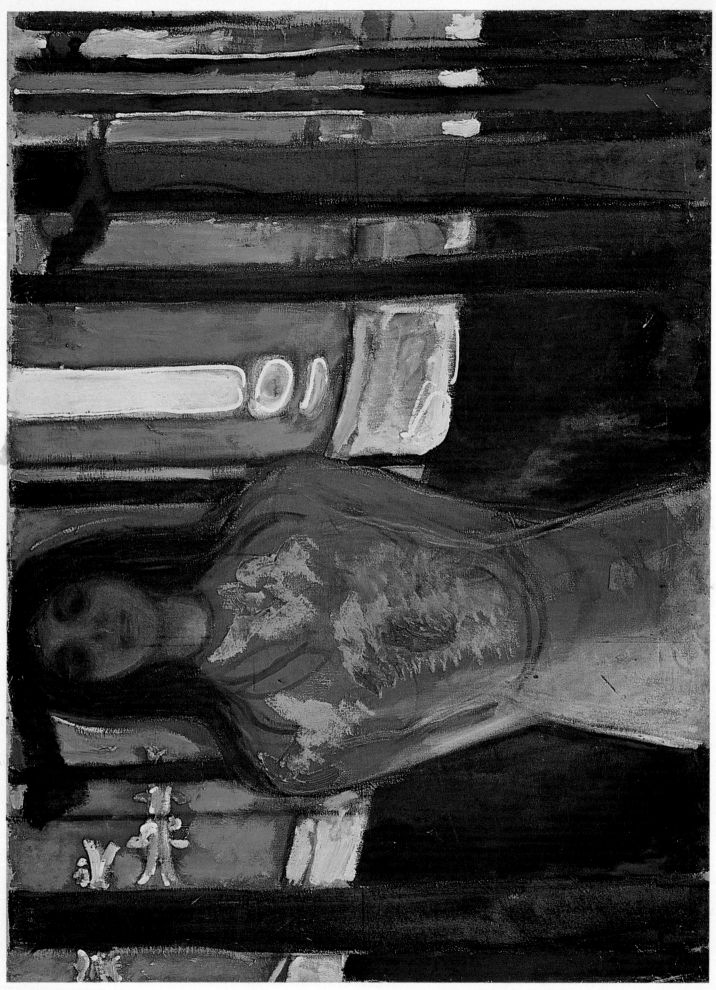

20. *Vampire*. 1895–1902. Oslo, Munch-Museet

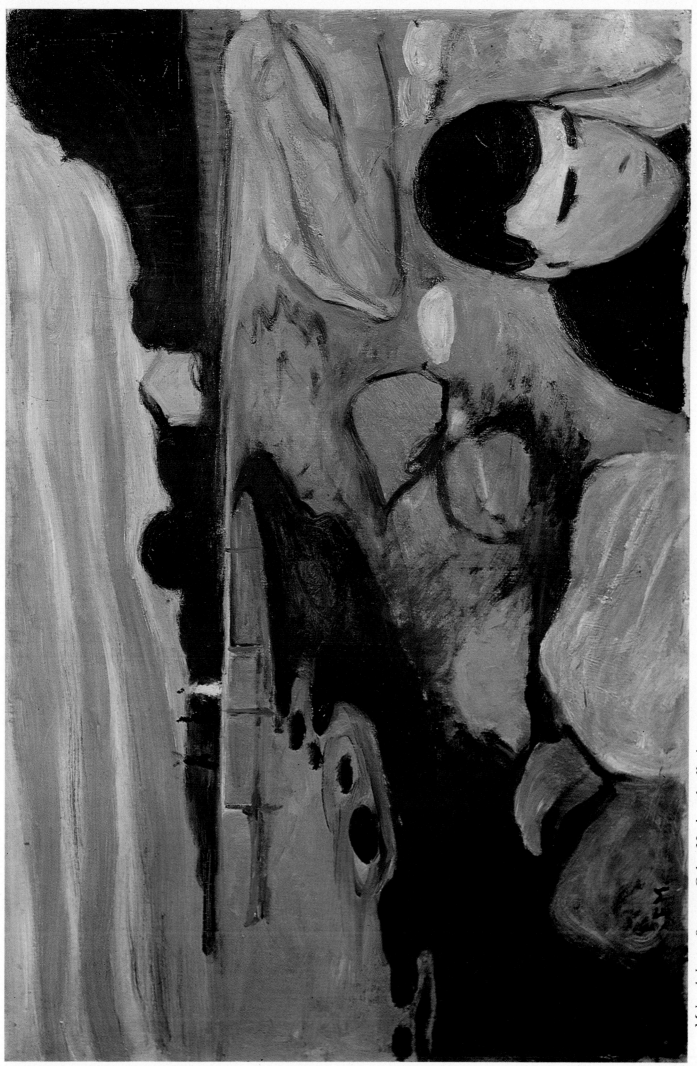

21. *Melancholy. c.*1892–3. Oslo, Nasjonalgalleriet

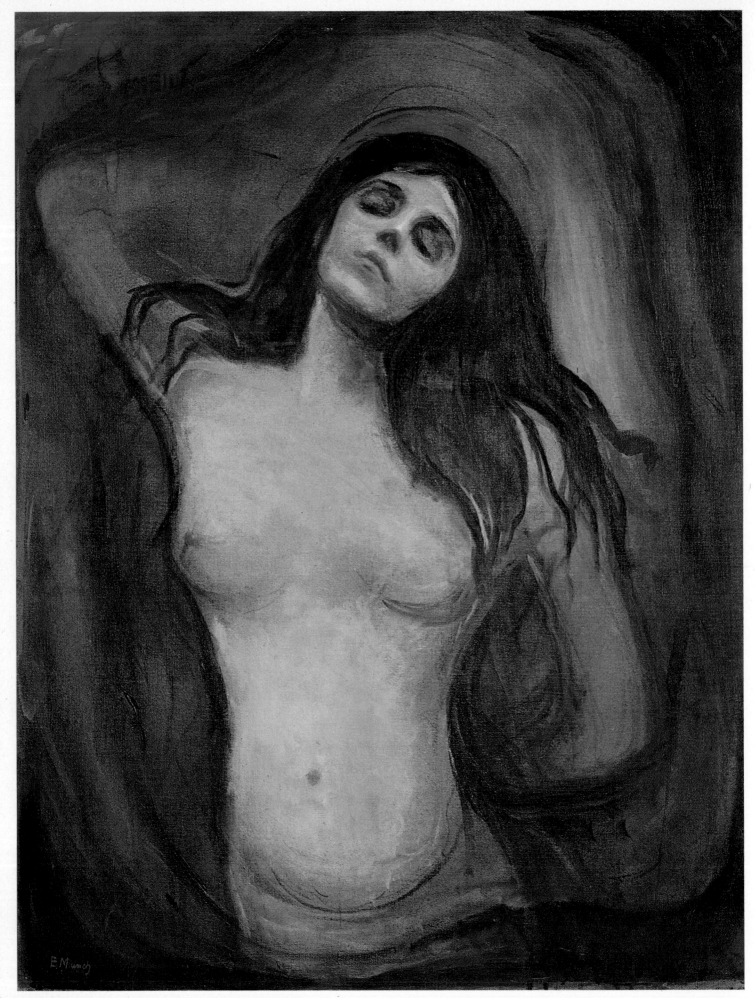

22. *Madonna. c.*1893. Oslo, Nasjonalgalleriet

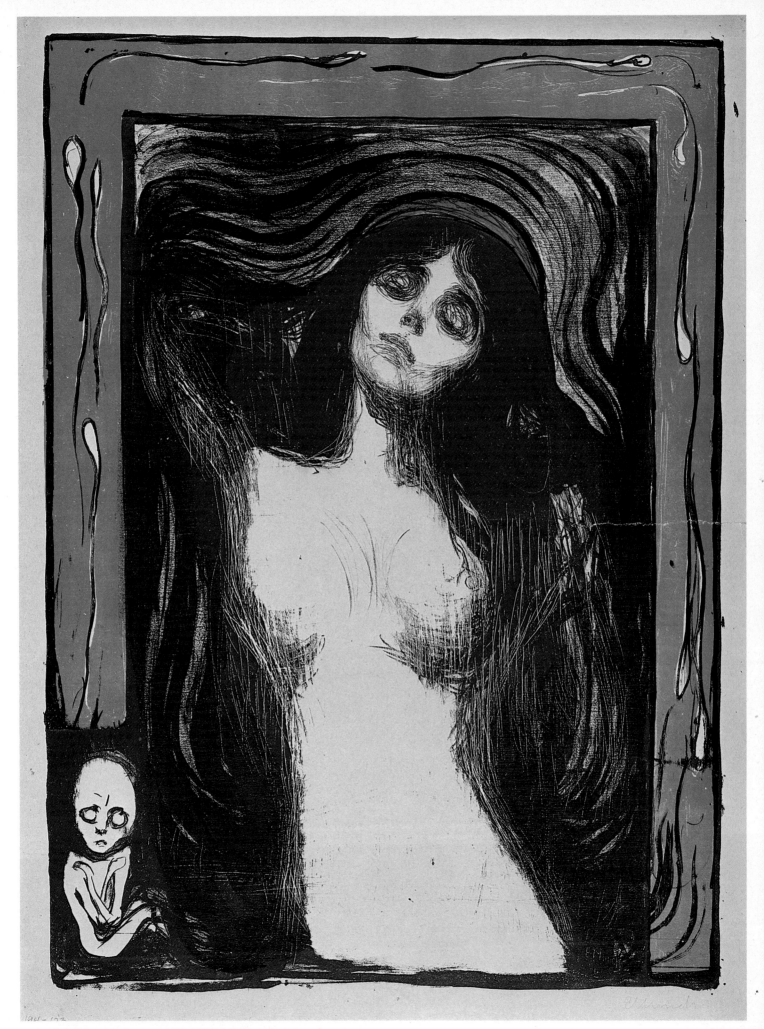

23. *Madonna.* 1895–1902. Oslo, Munch-Museet

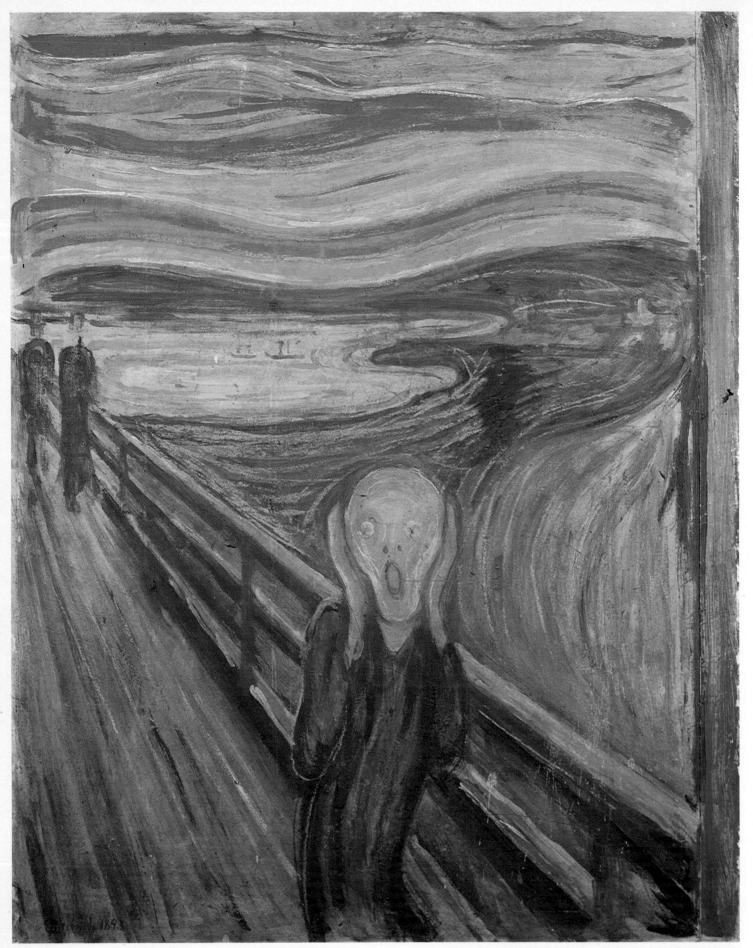

24. *The Scream.* 1893. Oslo, Nasjonalgalleriet

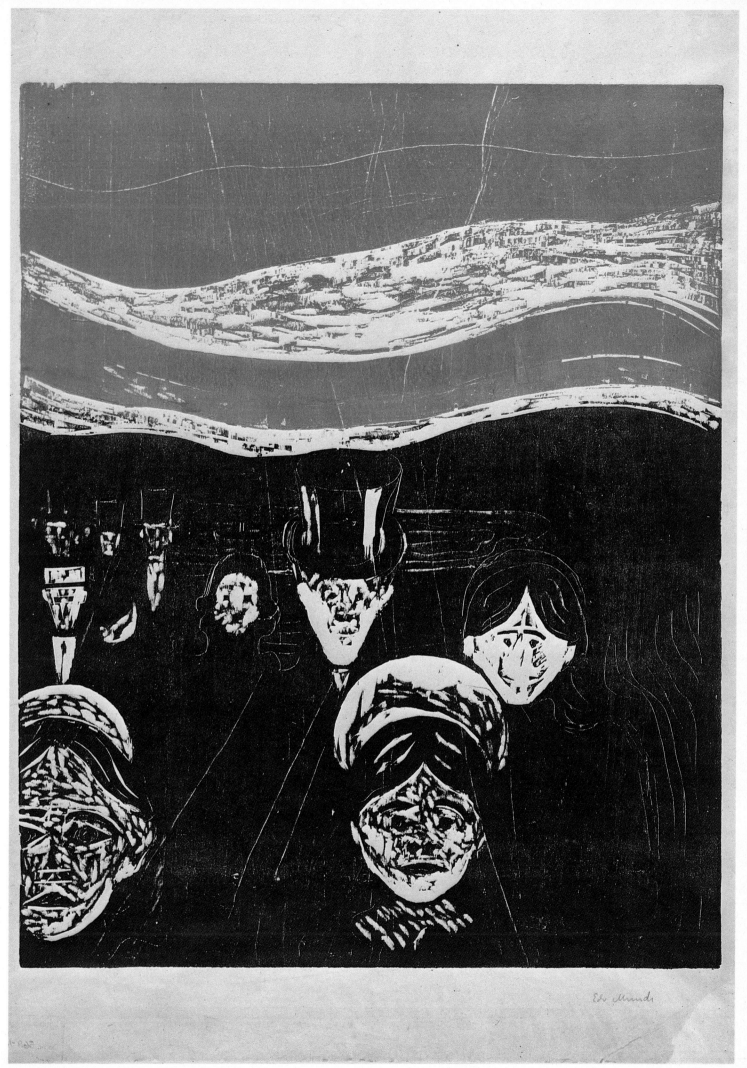

25. *Fear*. 1896. Oslo, Munch-Museet

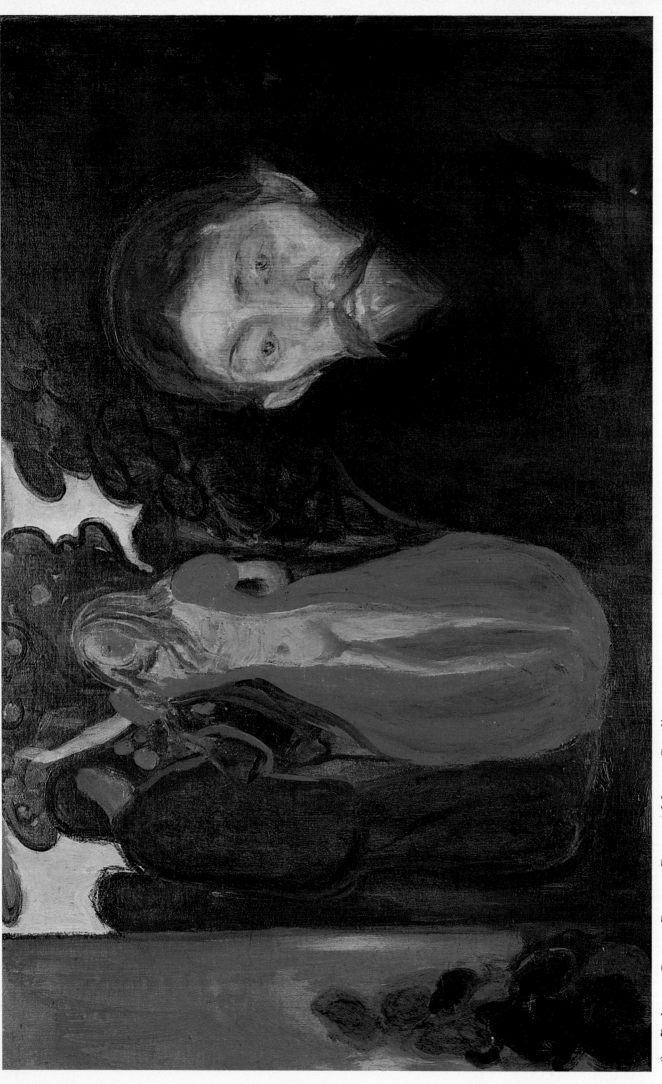

26. *Jealousy.* 1894–5. Bergen, Rasmus Meyers Samlinger

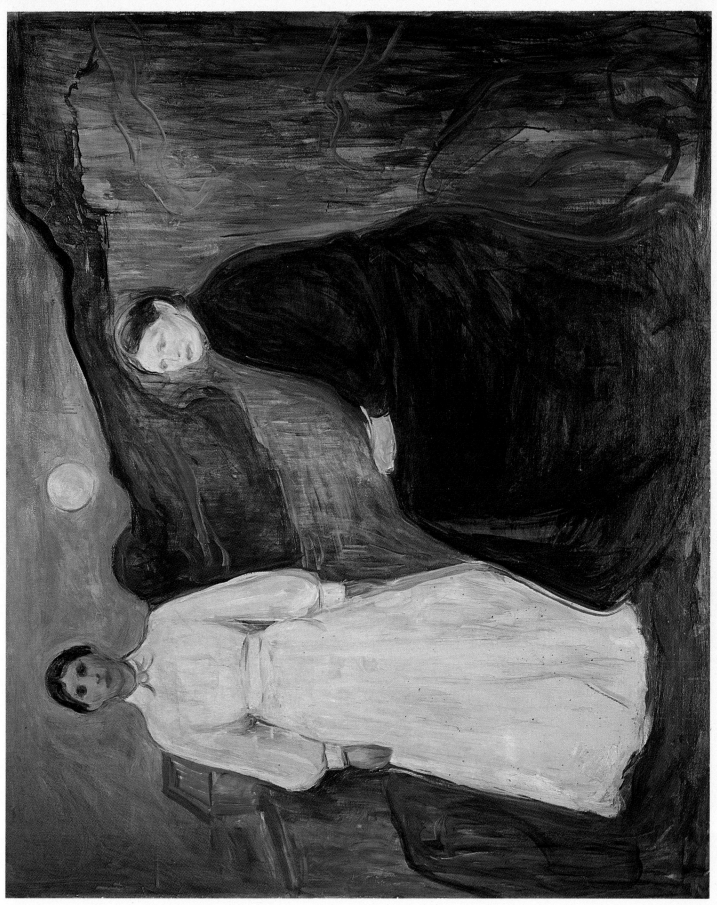

27. *Mother and Daughter. c.1897. Oslo, Nasjonalgalleriet*

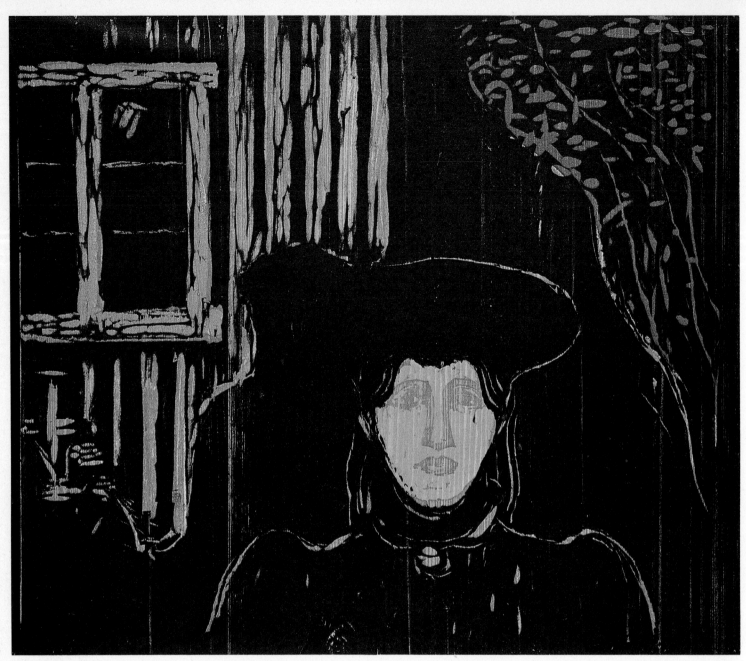

28. *Moonlight.* 1896. Oslo, Munch-Museet

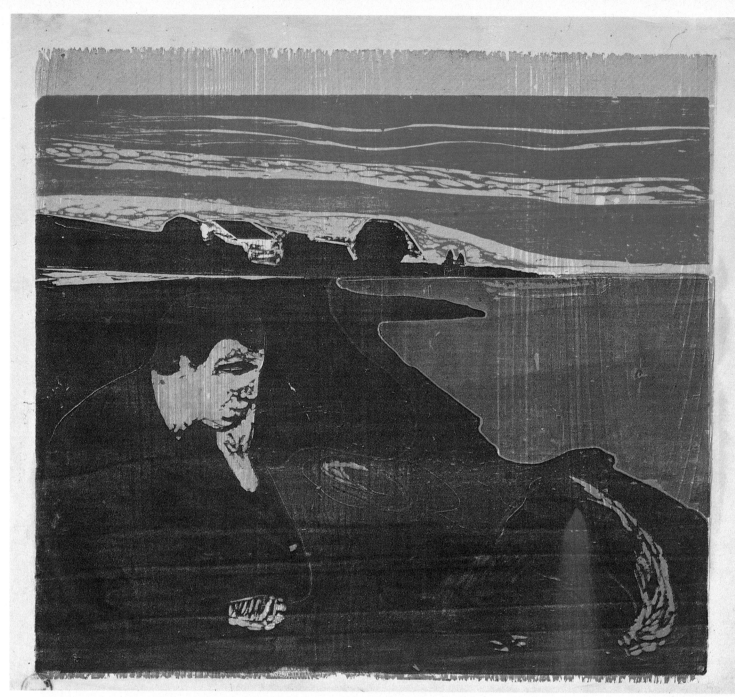

29. *Melancholy*. 1896. Oslo, Munch-Museet

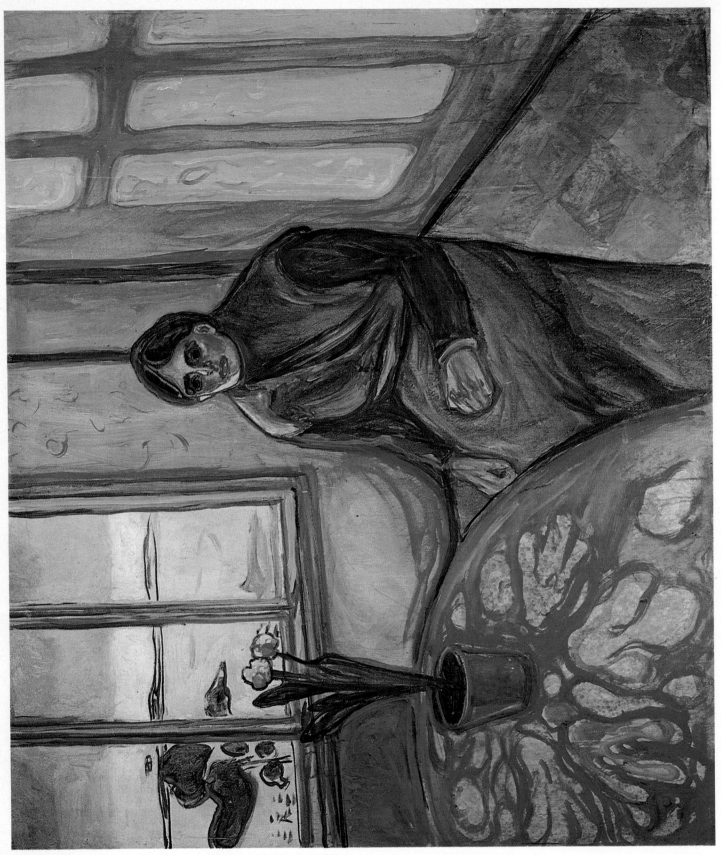

30. *Melancholy. (Laura)* . 1899. Oslo, Munch-Museet

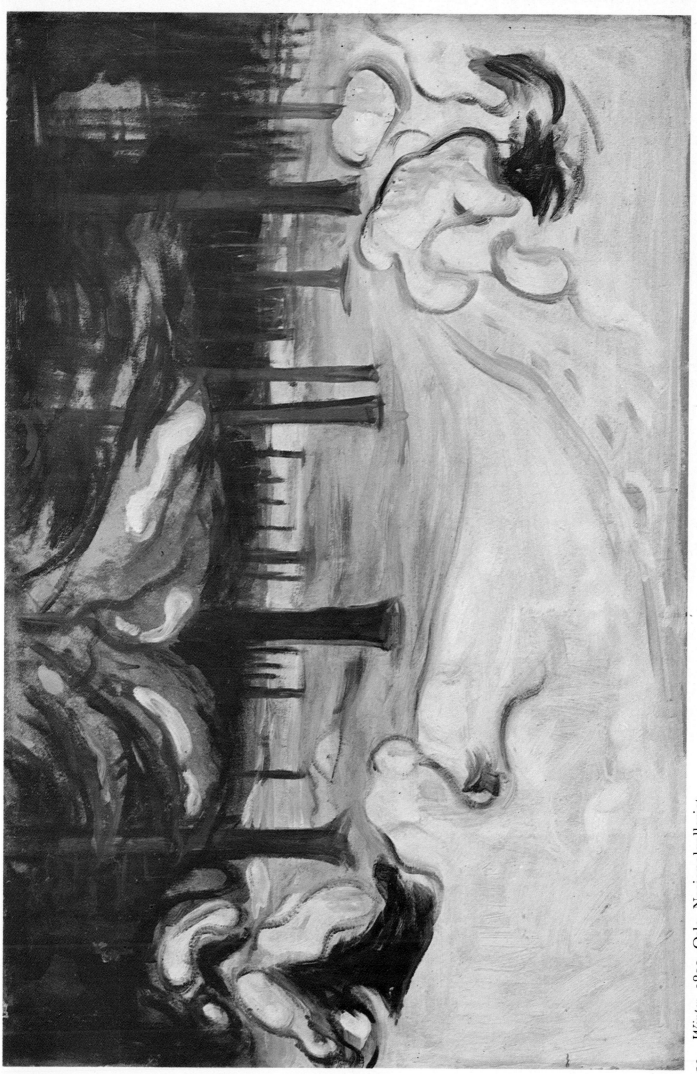

31. *Winter.* 1899. Oslo, Nasjonalgalleriet

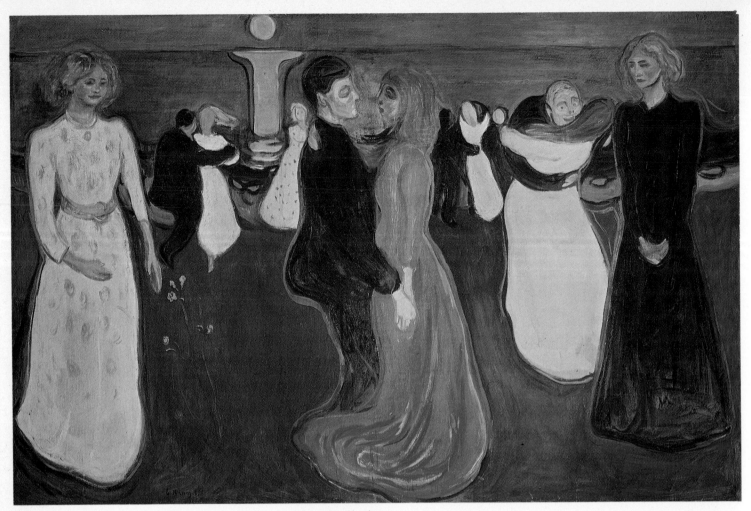

32. *The Dance of Life.* 1899–1900. Oslo, Nasjonalgalleriet

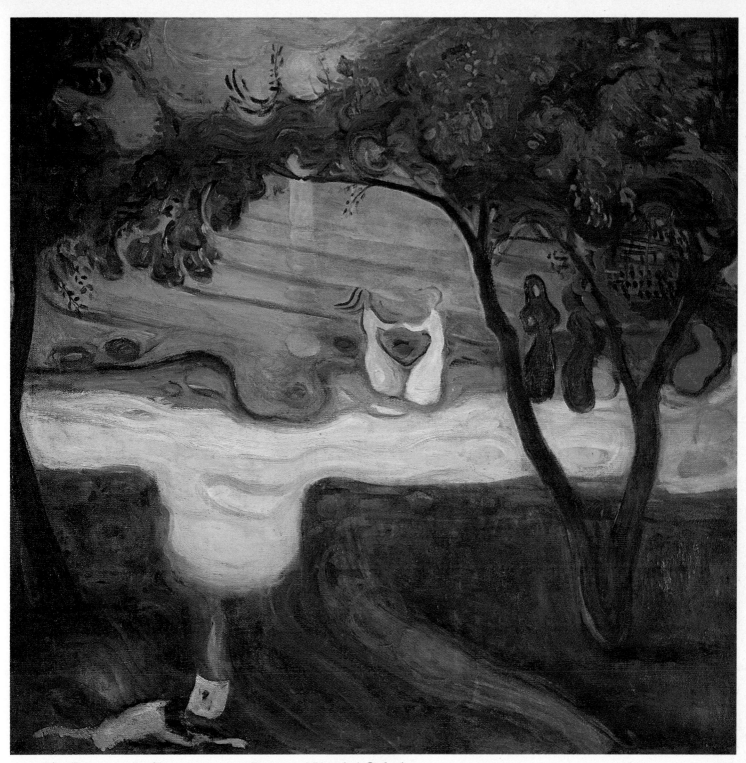

33. *The Dance on the Shore.* 1900–02. Prague, Národní Galerie

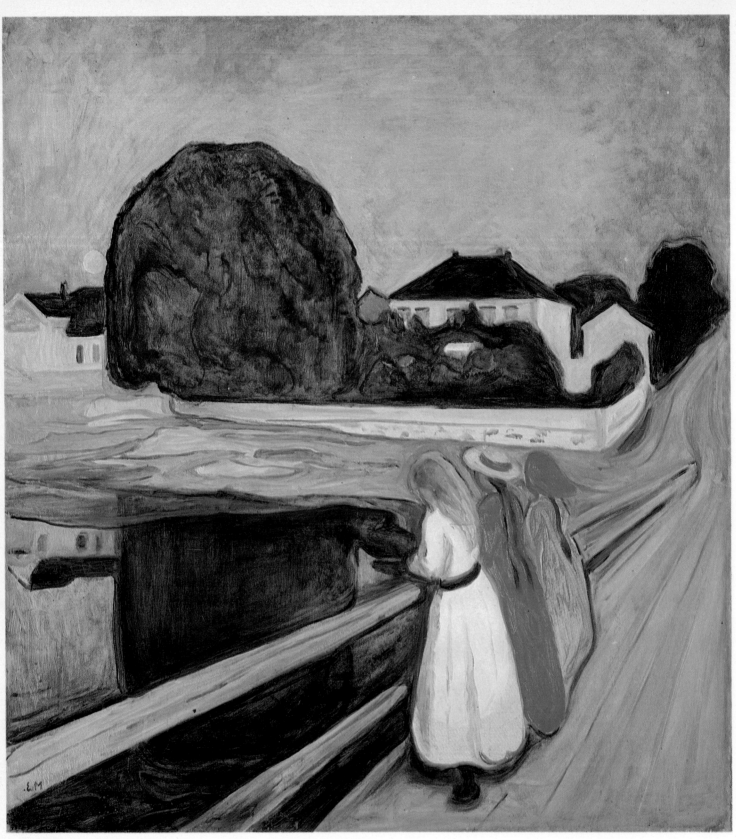

34. *Girls on the Jetty. c.*1899–1901. Oslo, Nasjonalgalleriet

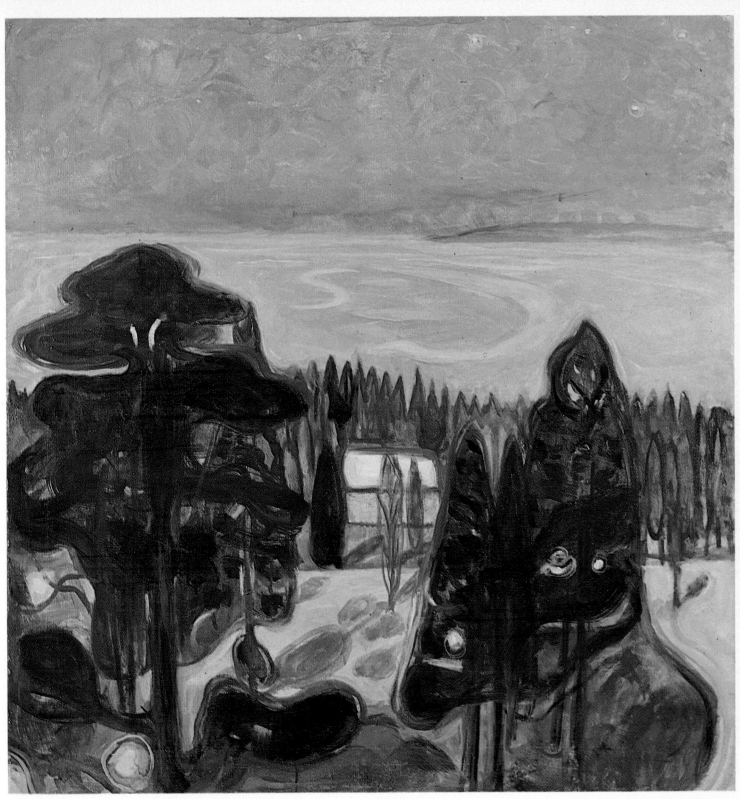

35. *White Night*. 1901. Oslo, Nasjonalgalleriet

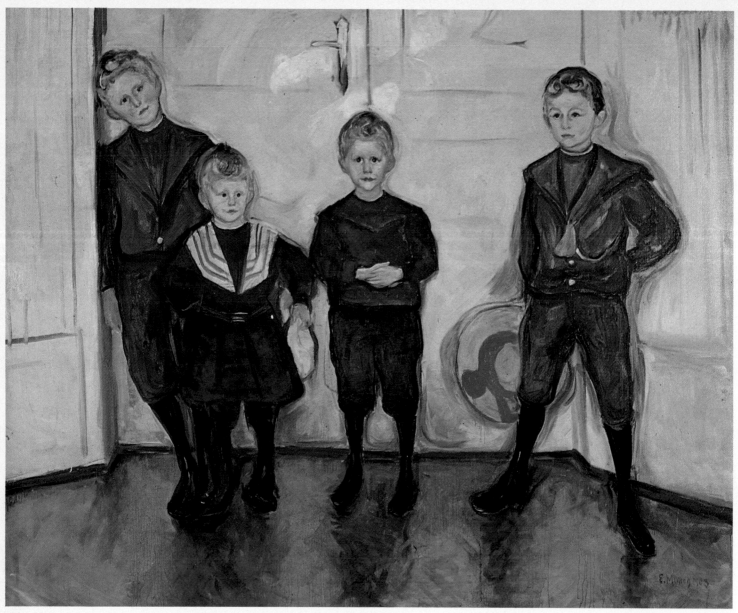

36. *The Four Sons of Dr. Max Linde.* 1903. Lübeck, Museum

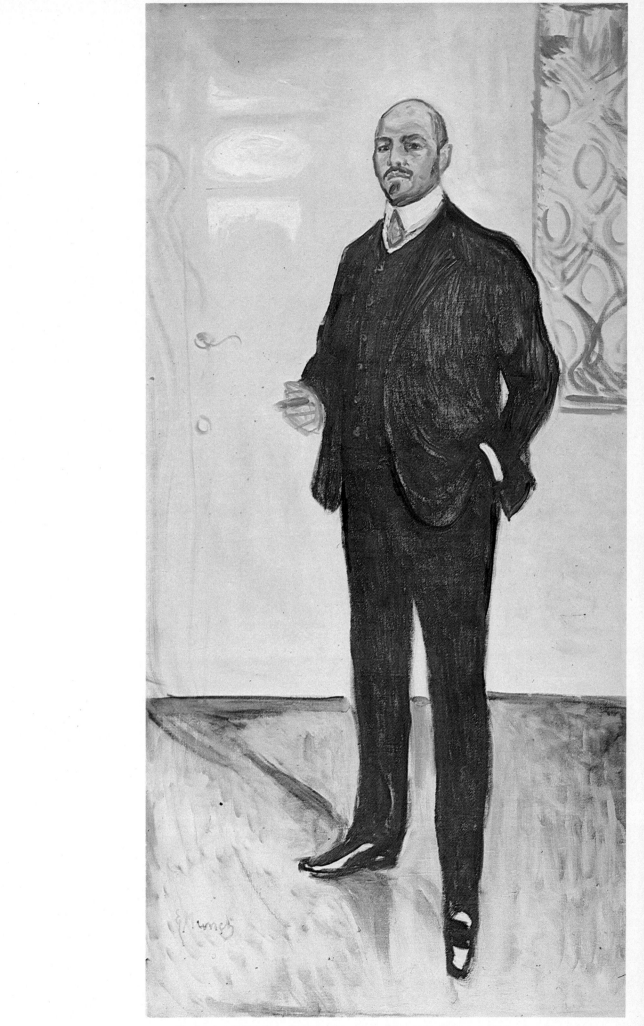

37. *Portrait of Walter Rathenau.* 1907. Bergen, Rasmus Meyers Samlinger

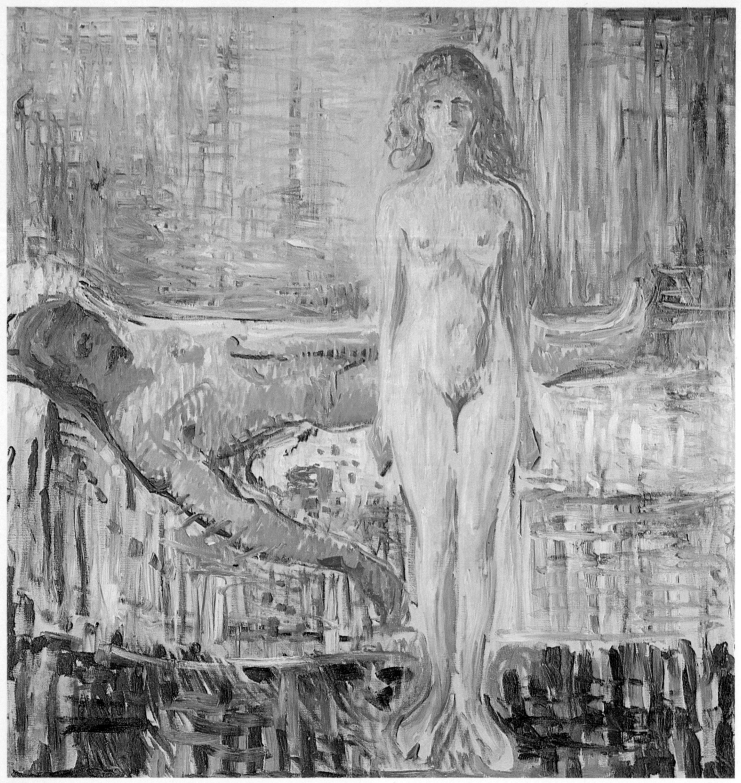

38. *Death of Marat.* 1907. Oslo, Munch-Museet

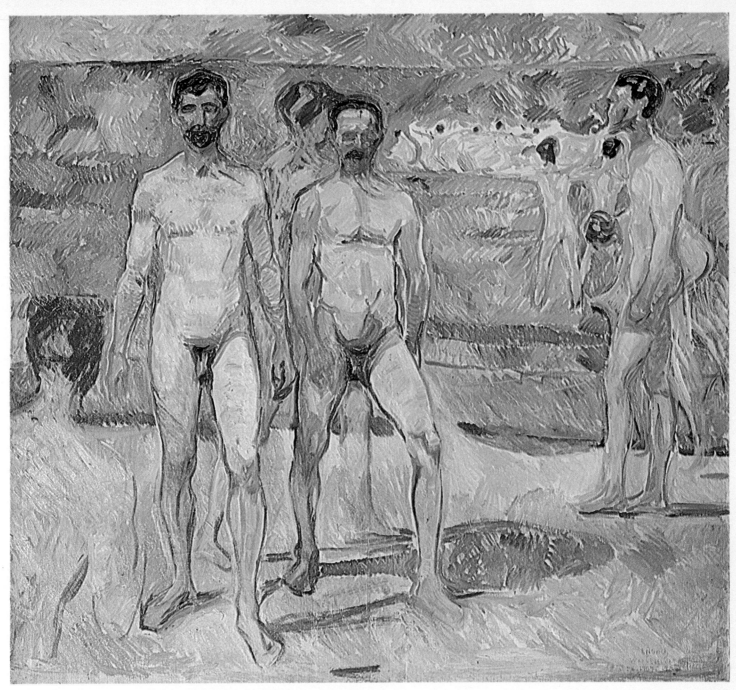

39. *Men Bathing*. 1907–8. Helsinki, Ateneumin Taidemuseo

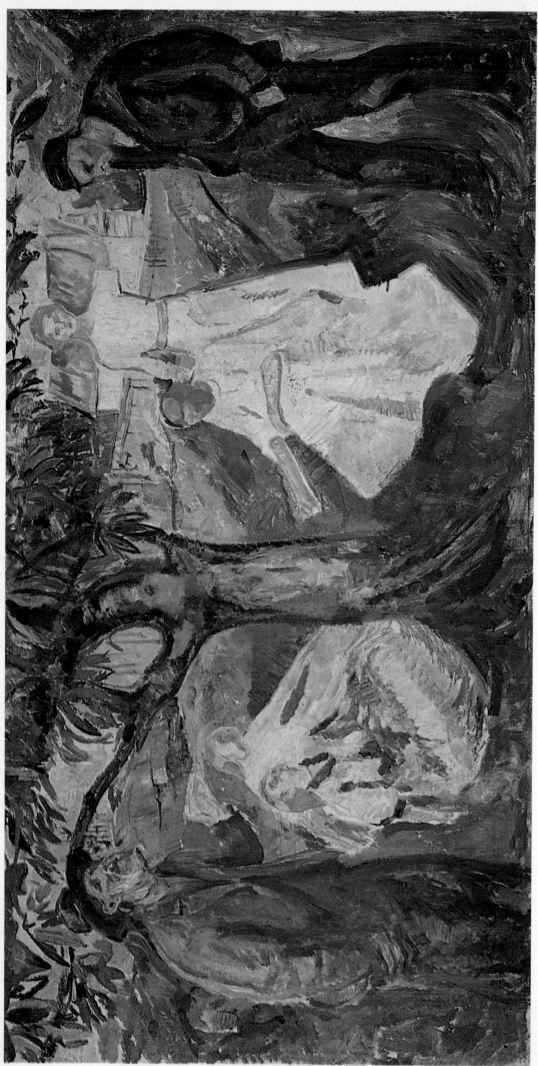

40. *Life.* 1910. Oslo, Town Hall

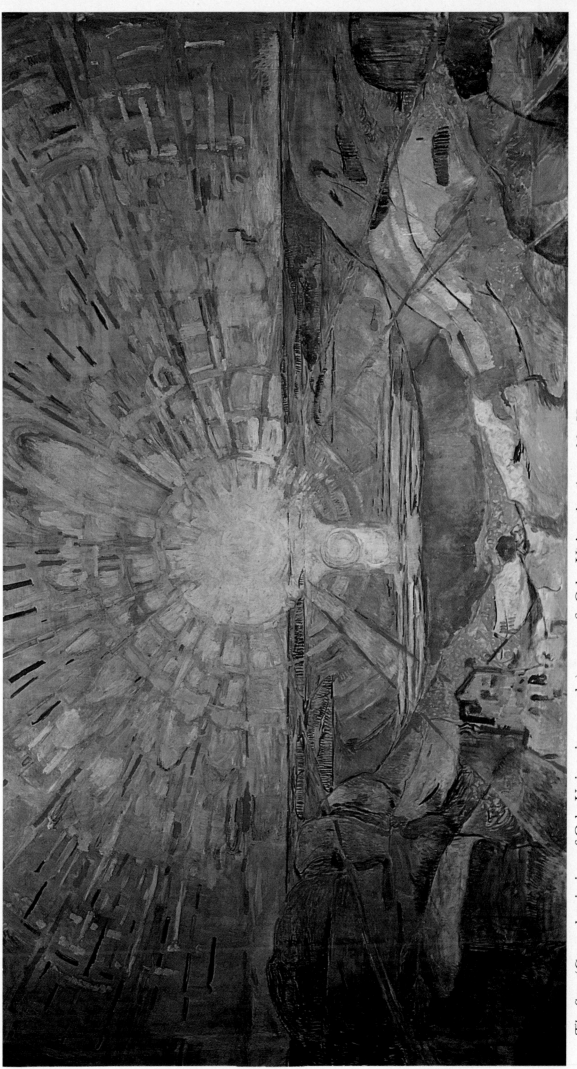

41. *The Sun.* (Central painting of Oslo University murals.) 1909–16. Oslo, University Assembly Hall

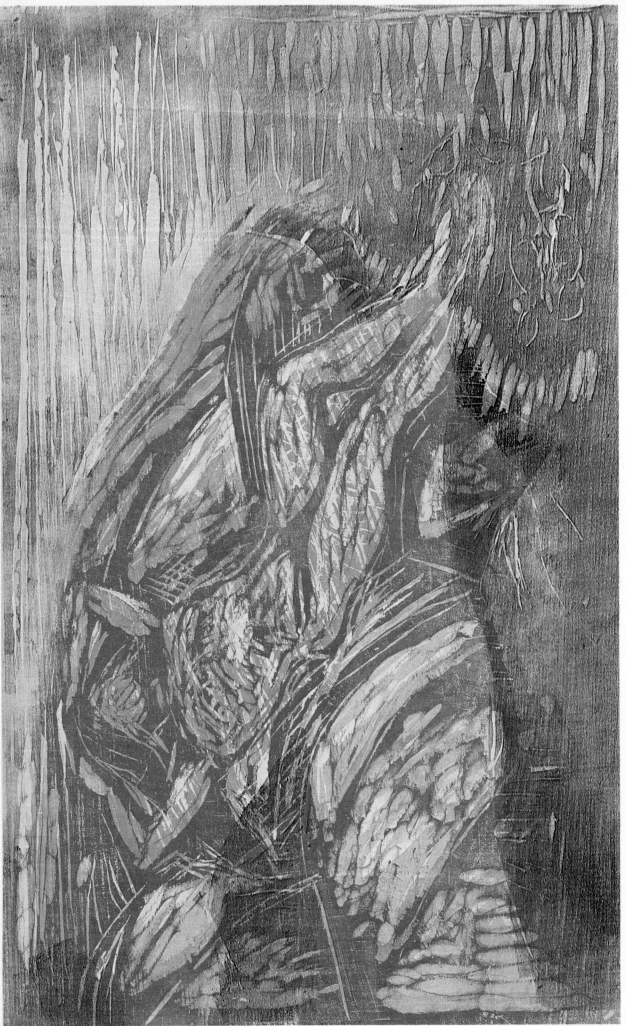

42. *Sunbathing. (Woman on the Rock)*. 1915. Oslo, Munch-Museet

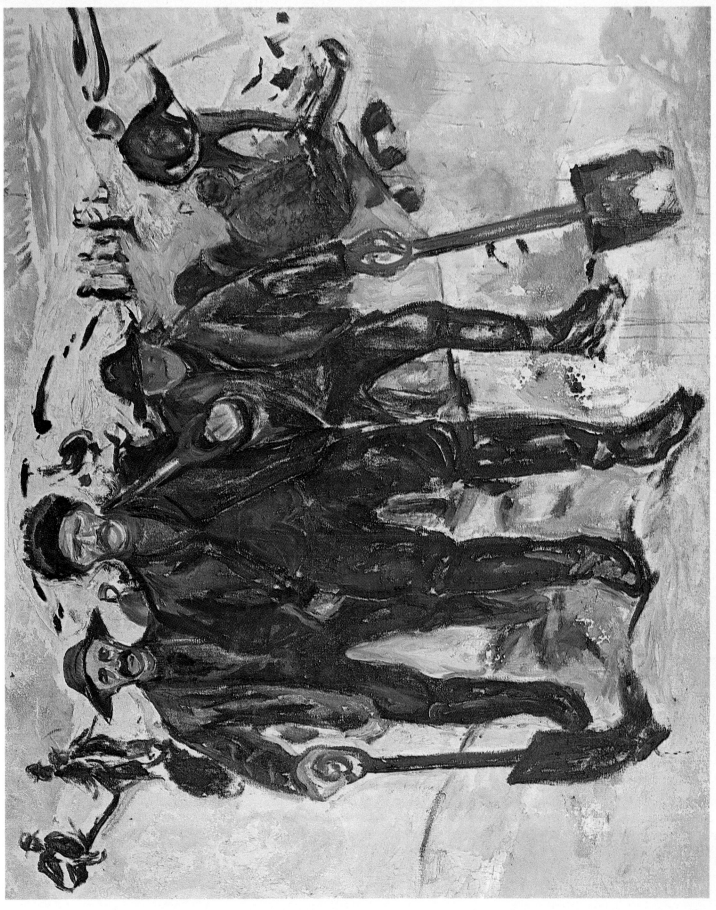

43. *Workmen in the Snow*. 1912. Oslo, Munch-Museet

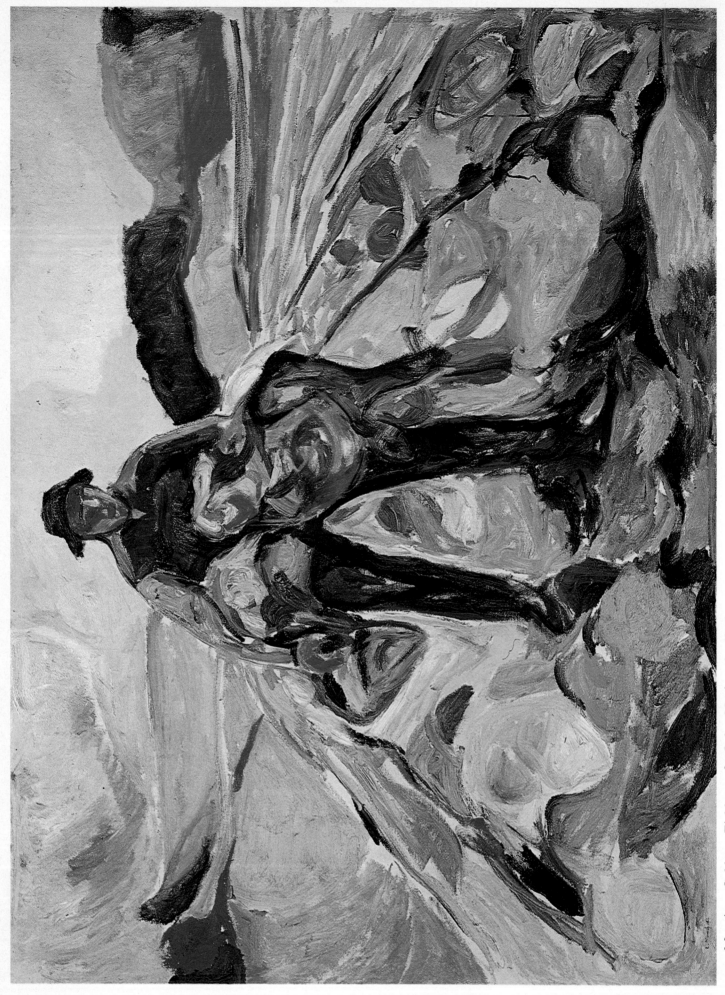

44. *Man in a Cabbage Field.* 1916. Oslo, Nasjonalgalleriet

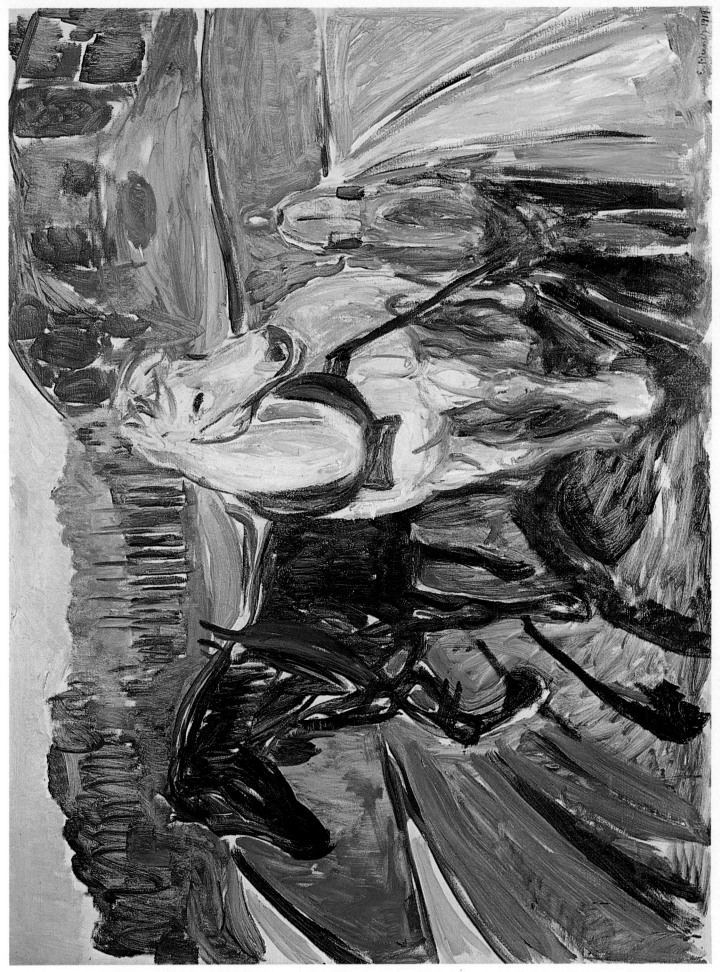

45. *Horse-team.* 1919. Oslo, Nasjonalgalleriet

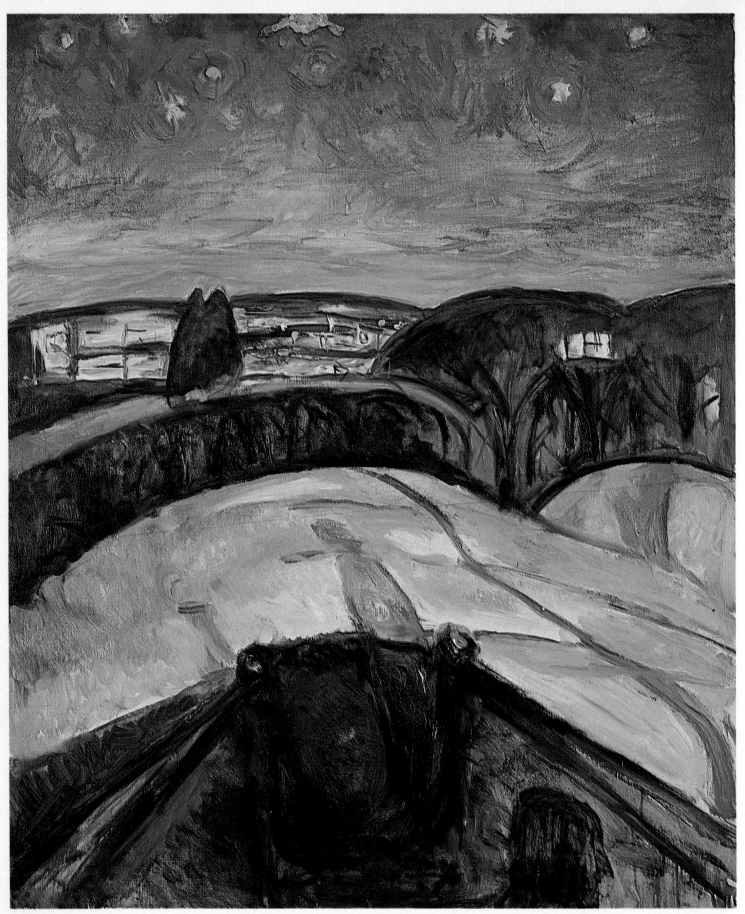

46. *Starry Night*. 1923–4. Oslo, Munch-Museet

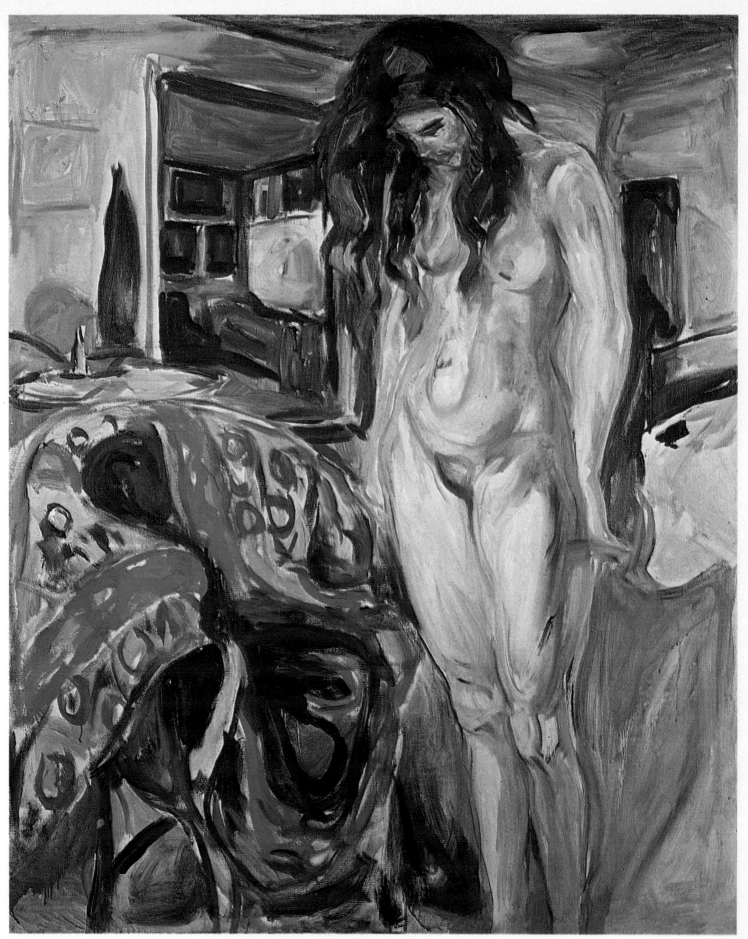

47. *Nude by the Wicker Chair.* 1929. Oslo, Munch-Museet

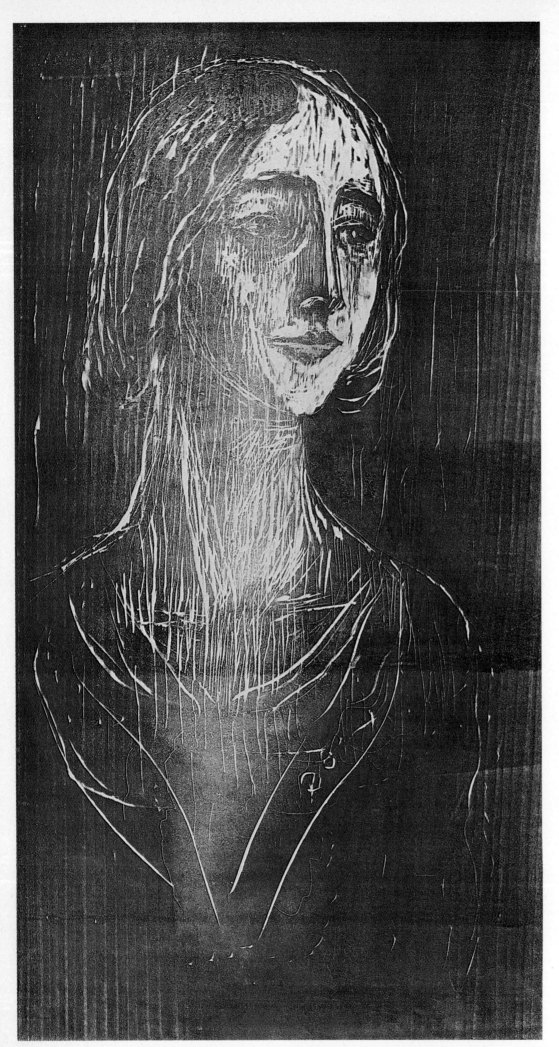

48: *Gothic Maiden. (Birgitte Prestøe)*. 1931. Oslo, Munch-Museet